The Scottish Colourists
1900–1930

Philip Long
with Elizabeth Cumming

F.C.B. Cadell

J.D. Fergusson

G.L. Hunter

S.J. Peploe

THE SCOTTISH COLOURISTS 1900–1930

National Galleries of Scotland
Edinburgh
in association with Royal Academy of Arts
London

Published by the Trustees
of the National Galleries of Scotland
on the occasion of the exhibition
The Scottish Colourists 1900–1930
held at the Royal Academy of Arts, London
from 30 June until 24 September 2000
and at the Dean Gallery, Edinburgh
from 4 November 2000 until
28 January 2001

ISBN 1 903278 04 X

Designed and typeset in Fairfield by Dalrymple
Printed by OZGraf SA

Front cover illustration:
S.J. Peploe, *Street Scene, France*, c.1910
[plate 6]

Frontispiece:
F.C.B. Cadell, detail from
The North End, Iona, c.1914
[plate 59]

Contents

Foreword

The term Scottish Colourist was not publicly used to denote the work of the four artists featured here until 1948. By that date, three of the four had been dead for more than a decade. During their lifetime, Peploe, Fergusson, Hunter and Cadell exhibited together on only three occasions. They never constituted a movement or school in any formal sense. And yet there are good reasons for treating the four artists as a group. They had certain things in common: a distinctive cultural background, a love of travel abroad, and a serious interest in recent developments in French painting, from Manet and the Impressionists to Cézanne, Matisse and the Fauves. They grew up in a climate dominated by the Glasgow Boys – a previous generation of artists, many of them French-trained, whose heightened colour and pronounced brushwork had liberated Scottish painting from the straitjacket of academicism. The Colourists in their turn had a profound impact on later generations of Scottish artists.

Of the four, Peploe and Fergusson were initially the closest, regularly to be found painting together in France during the first decade of the twentieth century. They also exhibited together in avant-garde shows in London before the First World War. Between 1924 and 1931 works by both artists were acquired by the French state. And over the last two decades they have both been included in large surveys of modern art, such as *Post-Impressionism* (Royal Academy), *Modern Art in Britain* (Barbican Art Gallery) and, most recently, *Le fauvisme ou 'l'épreuve du feu'* at the Musée d'Art moderne de la Ville de Paris. By contrast, the work of Hunter and Cadell is less well-known outside Scotland, in spite of the loyal efforts of a small number of commercial galleries, notably The Fine Art Society. This exhibition, then, is timely. It is particularly appropriate that it should be shown in London, which has recently reassessed English art of the same period, in exhibitions devoted to Bloomsbury and Roger Fry at the Tate and Courtauld Galleries respectively. London has probably not seen such a concentration of Scottish Colourist pictures since 1939, when works by Peploe, Hunter and Cadell were included in the huge *Exhibition of Scottish Art* at the Royal Academy. We are confident that visitors, whether in London or Edinburgh, will derive as much pleasure from looking at these paintings as the artists clearly had in making them – a sensuous delight in the colour, light, shapes and surfaces of the material world that cannot fail to lift the spirits.

This is the second time that the Scottish National Gallery of Modern Art and the Royal Academy have collaborated on an exhibition. In 1996 we worked together on the extremely successful *Alberto Giacometti* show and we have every confidence that *The Scottish Colourists* will prove equally popular.

We would like to thank Philip Long, Curator at the Gallery of Modern Art, and Isabel Carlisle, Exhibitions Curator at the Royal Academy, for selecting the exhibition so discerningly. Philip Long has also written the informative introduction to this catalogue and compiled a very useful chronology. Our thanks are also due to Elizabeth Cumming for writing a fascinating essay on the close relation between the four Colourists and France.

Lastly we would like to thank our respective sponsors, Dunfermline Building Society in Edinburgh and Flemings in London. Their tremendous support is greatly appreciated.

TIMOTHY CLIFFORD
Director, National Galleries of Scotland

RICHARD CALVOCORESSI
Keeper, Scottish National Gallery of Modern Art

PHILLIP KING CBE
President, Royal Academy of Arts

NORMAN ROSENTHAL
Exhibitions Secretary, Royal Academy of Arts

Sponsor's Foreword

Dunfermline Building Society is delighted to continue its support of the National Galleries of Scotland with its sponsorship of *The Scottish Colourists 1900–1930.*

Following a very successful five-year association with the Scottish National Gallery of Modern Art, during which we have supported exhibitions of the works of William Crozier, Anne Redpath, William MacTaggart, John Maxwell and Robin Philipson, it is particularly appropriate that the Society marks the new millennium by sponsoring this outstanding exhibition of the work of Cadell, Fergusson, Hunter and Peploe.

As a mutual organisation which returns consistent value to members and customers, we recognise also that we have a duty to the communities of Scotland, within which we operate. This exhibition is part of that community involvement, and we hope that the funds which we have provided to enable this exhibition to take place in Scotland will allow a wider access to the works of one of the most significant groups of painters to have emerged from Scotland.

I know that visitors to this exhibition will derive as much enjoyment as the Society takes pleasure in being associated with it.

DAVID SMITH
Chief Executive, Dunfermline Building Society

Acknowledgements

When this exhibition was first proposed we were delighted by the enthusiastic response we received from those who have collections of work by the Scottish Colourists. First and foremost, we would like to extend our thanks to the museums, galleries, corporate and private collectors, who have so generously agreed to lend to the exhibition. We would also like to thank the following who have helped towards the preparation of the exhibition and catalogue in numerous ways: Roger Billcliffe, Billcliffe Fine Art, Glasgow; Jamie Hunter Blair; Patrick Bourne, Bourne Fine Art, Edinburgh; William Bowie; Chris Brickley, Phillips, Edinburgh; Mungo Campbell, Hunterian Art Gallery, University of Glasgow; Valerie Fairweather, University of Stirling; Mr and Mrs Iain Harrison; Mr and Mrs Ronald Harrison; Tom Hewlett, Portland Gallery, London; Mr and Mrs Michael Innes; Gillian Kinloch; Victoria Law, Richard Green, London; Lord and Lady Macfarlane of Bearsden; Sheila McGregor, Walsall Art Gallery; Andrew McIntosh Patrick, The Fine Art Society, London; Jill MacKenzie; Mhairi McNeill, BBC Scotland; Dallas Mechan, Kirkcaldy Art Gallery and Museum; Jennifer Melville, Aberdeen Art Gallery; Duncan R. Miller, Duncan R. Miller Fine Art, London; Ewan and Carol Mundy, Ewan Mundy Fine Art, Glasgow; Paul Myners; Mark O'Neil and Jean Walsh, Glasgow Art Gallery and Museum; Mr and Mrs Owen-Jones; Guy Peploe, The Scottish Gallery, Edinburgh; Ian O'Riordan, City Art Centre, Edinburgh; Kirsten Simister, J. D. Fergusson Gallery, Perth; Selina Skipwith, Flemings; Joanna Soden, Royal Scottish Academy; Katie Swann, National Art Library,

Victoria & Albert Museum; Bernard Williams, Christie's Scotland; and Margaret Wilson. At the Royal Academy we would like to thank Sue Thompson (senior exhibitions organiser), Miranda Bennion (photographic and copyright coordinator), Roberta Stansfield (assistant photographic and copyright coordinator), and Andreja Brulc (photographic assistant). At the Scottish National Gallery of Modern Art we would like to thank Janis Adams (publishing manager), Alice Dewey (curator), Patrick Elliott (assistant keeper), Elizabeth Ficken (librarian), Graeme Gollan (conservator), Michael Gormley (curatorial secretary), Keith Hartley (assistant keeper), Margaret Mackay (assistant registrar), Keith Morrison (museum technician) and his colleagues, Alastair Patten (museum technician) and his colleagues, Ann Simpson (archivist), Lesley Stevenson (conservator) and Christine Thompson (publications assistant).

We would also like to thank the N.S. Macfarlane Charitable Trust for their support of the catalogue.

PHILIP LONG
Curator, Scottish National Gallery of Modern Art

ISABEL CARLISLE
Exhibitions Curator, Royal Academy of Arts

The Scottish Colourists: an Introduction

PHILIP LONG

In 1910, in the catalogue introduction to his exhibition *Manet and the Post-Impressionists*, Roger Fry wrote that Post-Impressionism was:

… widely spread … The school had ceased to be specifically a French one, it had found disciples in Germany, Belgium, Holland and Sweden. There are Americans, Englishmen and Scotsmen in Paris who are working and experimenting along the same lines.[1] The Scotsmen he refers to are most likely Samuel John Peploe (1871–1935, figure 1) and John Duncan Fergusson (1874–1961, figure 2), both of whom were at that time living in Paris as part of the international community of artists working in a Fauve style. If the artists included in Fry's exhibition were virtually unknown to the British public (some of the works had not even been seen by Fry prior to the opening), this was not the case with Fergusson and Peploe. Fergusson had moved to the French capital in 1907 and soon developed close friendships with artists whom he showed alongside at the Salon d'Automne, then the most progressive exhibiting society in Paris. Encouraged by Fergusson, Peploe joined him there in 1910, and for a short period both became part of bohemian Paris before the First World War.

In London, Fry's Post-Impressionist exhibition had, famously, introduced modern French art to the British public and this was followed by further group exhibitions expanding on this initial selection. Fry's 1912 *Second Post-Impressionist Exhibition* of British, French and Russian artists did not include work by either Peploe or Fergusson in the British section, which had been chosen by Clive Bell. The two Scotsmen's work could, however, be seen in a contemporaneous exhibition of American, English and Scottish artists, all of whom were based or had spent time in Paris. This was held at the Stafford Gallery, where both Peploe and Fergusson had exhibited earlier in 1912, just a few months after exhibitions of work by Gauguin and Cézanne. In 1913, Fergusson was represented in Frank Rutter's *Post-Impressionist and Futurist Art Exhibition*, held at the Doré Galleries. By then Fergusson, from his base in Paris, was active not only as an artist but also as a promoter of contemporary art, in his position as art editor of the London-based journal *Rhythm*, which shared its name with one of Fergusson's own works. For Peploe and especially for Fergusson, Paris was synonymous with all that was vital and energetic. Writing of the conducive atmosphere he found in the city, Fergusson proclaimed: *Something new had started and I was very much intrigued. But there was no language for it that made sense in Edinburgh or London – an expression like the 'logic of line' meant something that it couldn't mean in Edinburgh.*[2]

While the work of Peploe and Fergusson was seen regularly in London in the years prior to the First World War, the careers of George Leslie Hunter (1877–1931, figure 3) and Francis Campbell Boileau Cadell (1883–1937, figure 4), with whom they are now most closely associated, were at that point less developed. Cadell, who was twelve years younger than Peploe, had gone to Paris to study before 1900, but it was not until around 1910, when Peploe and Fergusson were making their way in Paris and London, that Cadell's career can be said to have begun seriously. A visit to Venice that year gave a spur to

[FIGURE 1]
S.J. Peploe
*Self-portrait, c.*1900
Scottish National
Gallery of Modern
Art, Edinburgh

left to right

[FIGURE 2]
J.D. Fergusson
Self-portrait, c.1902
Scottish National
Portrait Gallery,
Edinburgh

[FIGURE 3]
**Unknown
photographer**
G.L. Hunter, c.1929
Scottish National
Portrait Gallery,
Edinburgh

[FIGURE 4]
F.C.B. Cadell
Self-portrait, c.1914
private collection, on
loan to the Scottish
National Portrait
Gallery, Edinburgh

his work, inspiring him to paint in the loose, fluid manner characteristic of informal sketches in oil made by Peploe and Fergusson on earlier painting trips to France. By 1914, critics of Cadell's exhibitions in Edinburgh were able to associate his painting with modern French art.[3]

Hunter's life is the most erratic to follow of the four artists. Much of his early career was spent providing illustrations for magazines, and consequently he led a peripatetic lifestyle as he moved from city to city in search of work. Little is known of Hunter's painting prior to 1910, and the chronology of his subsequent art remains vague. What seems reasonably certain is that, like Fergusson, Peploe and Cadell, Hunter had visited Paris for an extended period by around 1905, and he continued making regular visits to France thereafter. In 1914 he was on the coast at Etaples, producing freely painted oils

that are closely comparable to the spontaneous approach developed variously by Peploe, Fergusson and Cadell in the period up to 1914.

These four painters, now known collectively as the Scottish Colourists, never constituted a formal group and only exhibited together on three occasions during their lifetime: the first in Paris in 1924 when all were mature artists. Indeed, the term 'Scottish Colourists' was only first used for an exhibition of the four's work in 1948, when three of the artists were long dead. Since the 1950s the use of this title has become increasingly common, but it was not until relatively recently that it has become associated exclusively with Peploe, Fergusson, Hunter and Cadell. Other Scottish artists, such as John Maclaughlan Milne for example, who was roughly contemporary with Cadell and who was in the south of France in the 1920s painting in a similar

manner to the four, might also be classified as a colourist. The first independent publication to treat the artists as a group, Tom Honeyman's *Three Scottish Colourists* of 1950, was based upon one specific collection and consequently did not include Fergusson. A major exhibition in 1970, organised by the Scottish Arts Council, was again restricted to Peploe, Hunter and Cadell. The concept of the four artists as indivisible took hold only in the 1980s, when a series of auctions devoted exclusively to their work reached a climax at the end of that decade, with unprecedented prices realised for their paintings. However, more than any other Scottish artists of this century, Peploe's, Fergusson's, Hunter's and Cadell's shared preference for vivid colour and fluid handling of paint entitles their close association.

All were born in Scotland, and with the exception of Hunter – whose origins were in the west and whose family emigrated to California when he was a boy – they all spent their childhood and early formative years in Edinburgh in relatively comfortable, middle-class surroundings. Born in 1871, Peploe wavered in his choice of career, eventually, in the early 1890s, giving up his apprenticeship in an Edinburgh legal firm to study at the Edinburgh School of Art. Fergusson, born in 1874, similarly abandoned his first plan to study as a naval surgeon in favour of a career as an artist. Like Hunter, he undertook no formal artistic training. But, by around 1894 he had established himself in a studio in Edinburgh. Born in 1883, Cadell's early aptitude for art received encouragement from his family and in 1899, aged sixteen, he left Edinburgh to study in Paris. Hunter was born in Rothesay on the island of Bute in 1877, but by around 1892 (when Peploe and Fergusson

were taking their first steps in their artistic careers) he and his family left Scotland for America. Hunter, therefore, had little exposure to the artistic environment then flourishing in Edinburgh and Glasgow, which nourished the aspirations of his Scottish contemporaries.

Edinburgh had long been perceived as the centre of the artistic establishment in Scotland and the focal point for this was the Royal Scottish Academy, whose membership for much of the nineteenth century had been made up of artists predominantly resident in the capital. From 1861, the east-coast bias of the Academy's annual exhibitions was countered in the west by the establishment of the Royal Glasgow Institute of Fine Arts. From its origins, the Institute took a more enlightened and imaginative approach to its annual exhibitions, including innovative work by English and foreign artists. It also admitted contemporary work by younger Scottish artists. Paintings by Fantin-Latour, Corot, Maris and Millet could be seen regularly on the Institute's walls from the 1870s onwards, and works by other foreign artists were frequently borrowed from local collectors in order to show the best in modern art. Degas, for example, was shown in Glasgow in 1892 and again in 1895, this time alongside work by Monet. This mirrored the London-based New English Art Club's contemporary policy of hanging works by Degas and the French Impressionists alongside those by the most progressive British artists.

Patrons of art in Scotland were not limited to the annual exhibitions of the Academy and Institute. In Glasgow and Edinburgh they were served by several dealers; two, in particular, were vital to the careers of the Colourists. Aitken Dott & Son, established in Edinburgh in 1842, gave Peploe his first solo exhibition in 1903, and Cadell, Fergusson and Hunter all had exhibitions there in subsequent years. In Glasgow, work by the four artists could be seen regularly at La Société des Beaux-Arts, the gallery established by Alexander Reid in 1889, following his return from Paris. There he had worked alongside Theo van Gogh for the dealers Boussod and Valadon, and through Theo's introduction had shared accommodation with Theo's more famous brother, Vincent. This experience meant Reid had been introduced to many young French artists. On his return to Scotland he brought with him works by Corot, Courbet, Degas and Daumier as well as by the Barbizon School, thus helping to inform the tastes and set the paths of many Scottish collectors.

The international spread of realism in painting developed on the continent by the Barbizon and Hague School artists, was taken up in Scotland by a group of young painters who began to exhibit in Glasgow in the 1880s. In 1885 at the Royal Glasgow Institute, James Guthrie, E.A. Walton, George Henry, James Paterson, John Lavery, William Macgregor and Arthur Melville exhibited paintings predominantly of realist subject-matter, executed with a broad handling of paint which appeared deliberately to eschew academic technique. Their subsequent success across Europe, and their acceptance by the Scottish artistic establishment (several of them received knighthoods) made them an obvious model for younger, aspiring Scottish artists. Several of the Glasgow Boys, as they came to be called, had spent extended periods in France, working in rural locations or in the Paris ateliers. Their continental experience had been vital in the development of their art, and although interest among English painters in French painting waxed and waned in the last years of the nineteenth century, the example of the Glasgow Boys strongly influenced many younger Scottish painters in their decision to study on the continent.

[FIGURE 5]
S.J. Peploe
Barra, 1903
Scottish National
Gallery of Modern
Art, Edinburgh

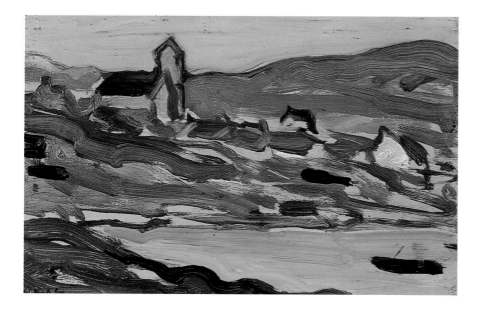

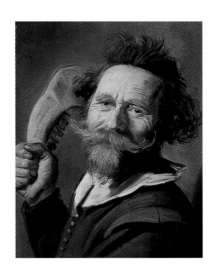

After his initial training in Edinburgh, Peploe left for Paris in the summer of 1894, where he studied at the Académies Julian and Colarossi. He later commented that the academic painter William Bouguereau, who taught at the Académie Julian, was a 'damned old fool', but his recollection of Colarossi's may have been fonder, as he received a silver medal there in 1894.[4] In Paris, Peploe shared accommodation with the Aberdeen-born artist Robert Brough, who had been a fellow student in Edinburgh. Brough may have continued on to Brittany later that year, but there is no evidence that Peploe accompanied him, and by 1895 Peploe had returned to Edinburgh and enrolled in the Royal Scottish Academy life classes. At about this time he took his first studio, in the Albert Buildings in the centre of the capital.

Although the development of Post-Impressionism in France is strongly associated with the period around 1890, artists arriving in Paris in the mid-1890s would have had limited opportunities to see work by those later identified as the leaders of the Post-Impressionist avant garde. Van Gogh had died in 1890, and although Gauguin was in Europe from 1893 (his Tahitian paintings were shown at the Galerie Durand-Ruel late that year), by 1895 he had returned to the South Seas. Cézanne had been working in comparative obscurity until 1895, when his work was exhibited by Vollard in Paris. Indeed, not until part of the collection of Gustave Caillebotte went on display at the Musée du Luxembourg in 1897, was it easy to see works by the Impressionists. Three years earlier, however, Brough and Peploe would have been able to see an exhibition at Durand-Ruel's of work by Manet, who had died in 1883. Of all nineteenth-century French artists, Manet affected Peploe's earliest work most significantly, both in painterly technique and approach to subject-matter. Peploe had begun to paint *en plein air* in around 1896 when he first worked in North Berwick, a coastal town east of Edinburgh, and in subsequent years he was frequently at work on Barra (figure 5). These loosely handled, brightly coloured oil sketches can be said to point towards Peploe's future development as a colourist, but for now Peploe followed Manet's example in executing his most ambitious paintings in the studio, and not out-of-doors.

Like Manet, Peploe took a serious interest in Old Master painting, visiting Holland in 1895 and returning with reproductions of works by Rembrandt and Frans Hals, which, according to his biographer Stanley Cursiter, were pinned to his studio wall alongside reproductions of works by Manet.[5] In Edinburgh, in the National Gallery of Scotland, Peploe had close to hand Hals's portraits of *A Dutch Lady* and *A Dutch Gentleman* (figure 6).[6] Peploe's loose brushwork and the immediacy of such portraits as *The Green Blouse* (figure 7), relate strongly to Hals's free use of paint and vigorous characterisation of his sitters. The subject of *The Green Blouse* was a gypsy flower girl, Jeannie Blyth, who sat for Peploe over several years. Another model used regularly by the artist was an Edinburgh vagabond,

left to right:

[FIGURE 6]
Frans Hals
(c.1580 / 85–1666)
A Dutch Gentleman
National Gallery of
Scotland, Edinburgh

[FIGURE 7]
S.J. Peploe
The Green Blouse,
c.1904
Scottish National
Gallery of Modern
Art, Edinburgh

[FIGURE 8]
S.J. Peploe
Man Laughing
(Portrait of Tom
Morris), **c.1902**
Scottish National
Gallery of Modern
Art, Edinburgh

[FIGURE 9]
Frans Hals
(c.1580 / 85–1666)
Verdonck
National Gallery of
Scotland, Edinburgh

Tom Morris (figure 8). Like Jeannie Blyth and like Hals's portrait of the peasant character Verdonck (figure 9), Morris provided Peploe with an unself-conscious subject well suited to his already bold handling of paint.

Peploe had also begun to paint still lifes, which initially shared the uniform low tonalities of his early portraits. An account by Frederick Porter, the artist's brother-in-law, describes Peploe's concentrated approach:

All his still life[s] were carefully arranged and considered before he put them on canvas. When this was done – it often took several days to accomplish – he seemed to have absorbed everything necessary for transmitting them to canvas. The result was a canvas covered without any apparent effort. If a certain touch was wrong it was soon obliterated by the palette knife. The whole canvas had to be finished in one painting so as to preserve complete continuity. If, in his judgement, it was not right then the whole painting was scraped out and painted again.[7]

Peploe's lengthy preparation for these works can be contrasted with the commonplace of their subject-matter: painting materials, wine bottles, books, fruit, all set against a dark or muted background.

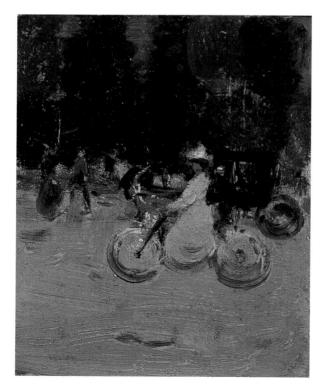

[FIGURE 10]
J.D. Fergusson
Girl on a Bicycle,
***c.*1902**
Lord and Lady
Macfarlane of
Bearsden

Prior to his first solo exhibition in Edinburgh in 1903, Peploe exhibited little and there is nothing deliberately commercial about any of these first canvases. However, they soon grew in ambition. In *The Lobster* (plate 1) the introduction of strongly coloured objects against a dark background is highly dramatic. The artist's vertical signature, making a prominent appearance in the upper right corner, is part of the sparse composition. Peploe would later include more literal references to Japanese art in his painting, such as the coloured woodcut which appears in *Interior with Japanese Print* (figure 47). In this earlier work of *c.*1903, his signature is contrived to appear like Japanese script. Barely perceptible shadows and a colour scheme of red, yellow and black combine with the painting's sheen to give an effect comparable to Japanese lacquer-work.

James McNeill Whistler, perhaps the principal exponent of *Japonisme* in Britain, exerted a powerful influence on numerous Scottish artists in the latter part of the nineteenth century. The Glasgow Boys in particular led this interest, following Whistler's adage that an artist should be free to select his own subject and see beauty wherever he chooses. Henry and Hornel took the interest in *Japonisme* most seriously, setting off for an eighteen-month visit to the Far East in 1893, financed in part by Alexander Reid, who showed Hornel's Japanese canvases in Glasgow in 1895. All four of the Colourists are likely to have seen the flurry of Whistler exhibitions held in Edinburgh, Paris and London between 1904 and 1905 (following the artist's death in 1903). These shows included Whistler's infamous fireworks paintings, to which Fergusson's own depiction of Bastille-day celebrations at Dieppe (plate 21) is a clear homage. Later, Fergusson wrote of Whistler, describing him as:

… a fighter, a man of feeling, of sensibility, not muddleheaded enough to be impressed by academic sensibilities. A man with a real sense of design, a real sense of colour and quality of paint … but above all confidence in himself.[8]

By 1905, the date of Fergusson's Dieppe painting, he and Peploe were close friends, and Peploe is depicted in the work, wearing a grey suit and cap, standing with his back to the viewer. Peploe and Fergusson

painted together in France for the first time in 1904, and although it is not known precisely when they first met, the close pattern of their early careers accounts for the strong friendship which quickly sprang up between the two.

Unlike Peploe, Fergusson had no formal art education in Edinburgh, preferring to remain self-taught. He had a disinclination to remember dates correctly (Margaret Morris recalled he couldn't remember his birthday)[9] and it is difficult to be exact about his early movements. By the time Peploe was studying in Paris, Fergusson had moved to a studio in Edinburgh's Picardy Place and had begun to work around the streets of the city, producing numerous small, rapidly executed oil sketches. To aid him in this he constructed a portable paint box, the lid of which could be used as a palette. Whereas Peploe's works executed out-of-doors are relatively unpopulated, Fergusson's, by comparison, are full of metropolitan charm: figures mill on Princes Street; a young woman passes by on a bicycle (figure 10). Fergusson's interest in the vitality of his surroundings would continue as a preoccupation in his work and, when eventually he moved to Paris,

he settled easily into the freewheeling café society of the Left Bank.

It is not clear when Fergusson made his first visit to the French capital. In an outline for a proposed autobiography, he notes associating with other young foreign artists in the city in 1895.[10] In a memoir of Peploe he recalls their meeting after both had admired the Impressionist paintings at the Salle Caillebotte at the Musée du Luxembourg, which opened in 1897. He also notes his occasional attendance at the life classes of the Académie Colarossi.[11] He was in France in 1898, painting on the River Loing, where at the popular artists' colony of Grez, John Lavery, Edward Stott and Frank O'Meara had worked in the previous decade. In 1899 Fergusson went further afield, following Arthur Melville's footsteps in North Africa, painting watercolours (figure 11) which are clearly related to Melville's sophisticated blottesque technique (figure 12). Melville formed the most tangible link between the young Colourists and the Glasgow Boys. A close friend of the Cadell family, Melville had advised Francis's father that Bunty (as Cadell was known from an early age) would benefit more from study-

ing art in Paris than in Edinburgh. Fergusson in turn wrote that Melville was his first influence: *Although I never met him or even saw him, his painting gave me my first start: his work opened up to me the way of free painting – not merely freedom in the use of paint but freedom in outlook.*[12] Fergusson received further encouragement from another member of the Glasgow School, Alexander Roche, who admired the younger artist's earliest exhibited paintings at the Society of Scottish Artists in Edinburgh in the 1890s. When they met in Roche's Edinburgh studio, Fergusson expressed admiration for a study made by Roche after Velázquez. Roche lent the work to Fergusson and he made copies from it.

A substantial monograph on Velázquez, published in 1895 by the Edinburgh-born art-historian, R.A.M. Stevenson, claimed Velázquez for Impressionism and generated new interest in his work. Together with many other British artists at this time, Velázquez's virtuoso composition, brushwork and approach to colour affected both Peploe and Fergusson. The significance attached to the objects in Peploe's *The Lobster* is comparable to Velázquez's *bodegones*, his early paintings which monumentalise everyday subjects. Fergusson's early studio paintings have a restraint similar to Peploe's first still lifes and portraits. Yet in Fergusson's intimate portrait of *Jean Maconochie* (plate 17) his interest in tonal values is combined with supple brushwork, which finds free range in the flourish of the scarf knotted under the sitter's chin. In the still lifes which followed, such as *Jonquils and Silver* (figure 13, see also plate 18), the even tone of Fergusson's painting becomes cool and silvery (like Velázquez's later palette) and colour takes on a new importance.

Fergusson's *Jonquils and Silver* of 1905 is similar to the series of still lifes developed by Peploe at about the same time, where a white tablecloth is laid with a few objects and positioned against a dark brown or almost black background. Commonplace items which one might expect to find around a painter's studio were replaced by silver, glassware, roses and fans, adding a sophisticated narrative appeal, seen at its height in the after-dinner mood of Peploe's *Still Life with Coffee Pot* (plate 4). These

still lifes were executed following Manet's technique, Peploe first painting in light areas and then adding darks and half-tones while the paint remained wet. This method is combined with the artist's increasingly fluid brushwork, the strokes of sweeping paint and bold highlights making their own independent pattern.

The scale of Fergusson's still-life painting during this period was, by comparison, less ambitious. Unlike Peploe, it was not in his nature to spend long periods working in the seclusion of his studio. From about 1904 Fergusson's visits to France increased in regularity and he finally moved there in 1907. His work had been featured in *The Studio* in April of that year, and this provided him with useful connections when he arrived in Paris.[13] He soon found a studio, at 18 Boulevard Edgar Quinet in Montparnasse:

[it was] comfortable, modern and healthy. My concierge most sympathetic. Life was as it should be and I was very happy. The Dôme, so to speak, round the corner; L'Avenue quite near; the 'Concert Rouge' not far away – I was very much interested in music; the Luxembourg Gardens to sketch in; Colarossi's class if I wanted to work from the model. In short everything a young painter could want.[14]

In 1907 he exhibited for the first time at the Salon d'Automne, although the works hung there, three portraits and *Dieppe, 14 July 1905: Night*, were not his most recent.[15] By 1907 his painting had already developed strong Fauvist tendencies (exemplified by *Closerie de Lilas* (plate 24), which shows the American artist Anne Estelle Rice) and he would have been aware of the cautious note his earlier work sounded alongside that of Matisse, Derain and Vlaminck at that year's Salon.

Fergusson soon took his place among the painters working in a Fauvist style, producing portraits and street and café scenes painted in strident, pure colours. *Closerie de Lilas*, along with other works from this Paris period, has an apparently deliberate clumsiness of handling, wholly in tune with the expressionistic aims of the Fauves. In subsequent portraits, of Anne Estelle Rice (plate 25) and Yvonne Davidson, who features in *The Blue Hat, Closerie de*

[FIGURE 13]
J.D. Fergusson
Detail from
Jonquils and Silver,
1905
Robert Fleming
Holdings Ltd, London
See also plate 18

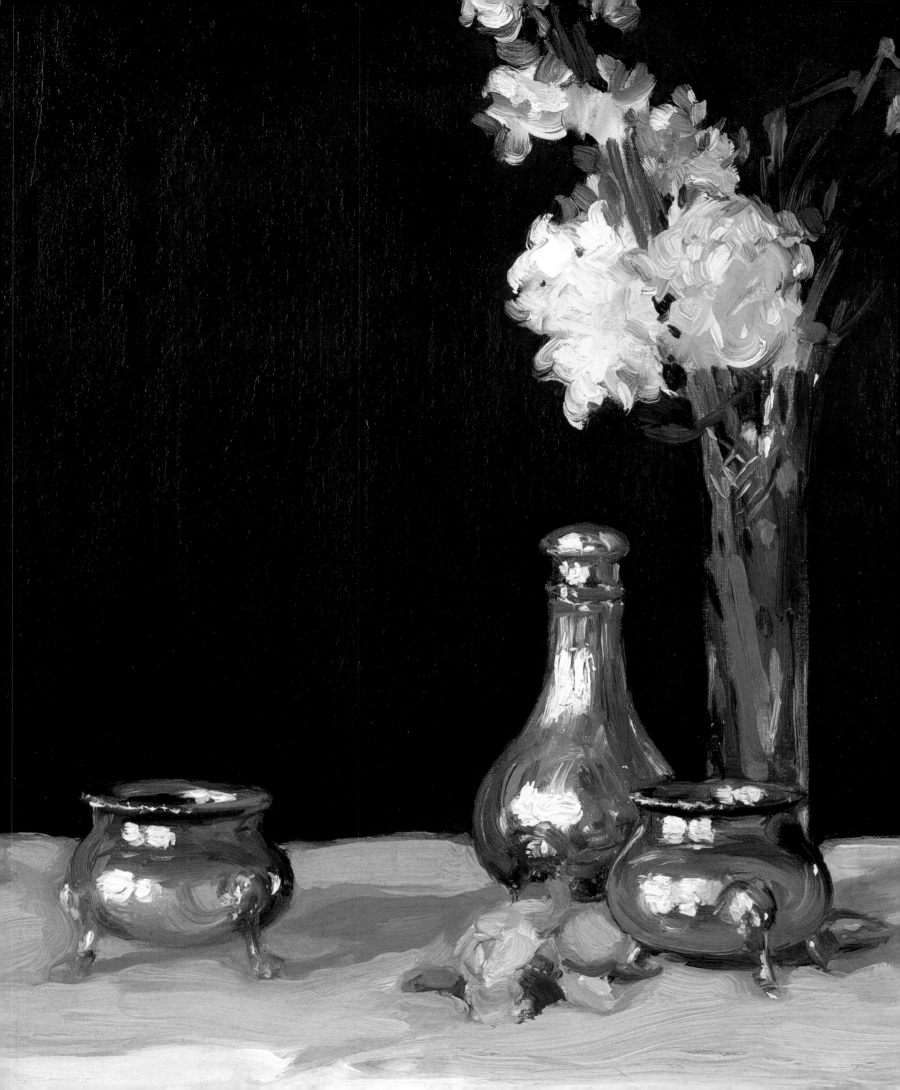

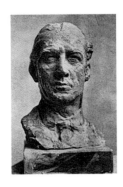

Lilas (plate 28), Fergusson's colours are less strident and now contained within black outlines which unify the surface and emphasise the pattern of his compositions.

The Parisian, Yvonne de Kerstratt, had married the American sculptor, Jo Davidson, in 1909, and together with the artists Rice, Bertha Case and Jessie Dismorr made up part of Fergusson's circle. A close early friend was André Dunoyer de Segonzac, whom Fergusson met while teaching at the Académie de la Palette, but Fergusson's closest associations remained within this group of Anglo-American artists. Davidson noted the important influence the older Fergusson had upon him then and described him as the *'chef d'école* of a group in Paris who called themselves Post-Impressionists'.[16] Davidson produced a bust of Fergusson (figure 14) and left an engaging account of the experience: *Johnny had a head for sculpture, a fine aquiline nose and a tightly-drawn skin. He looked all the Scottish chieftan. I worked intensely for two hours. Johnny insisted we stop and go to L'Avenue's for a* drink. *Once there he was eloquent on what a swell job I had done. 'You must not touch this', he said, and he argued with me to cast it as it was. I went to bed that night in a happier mood. Perhaps I was an artist after all.*[17]

For Fergusson, Paris provided the perfect environment for his developing *métier* and in his letters back to Peploe, in which he wrote 'trying to explain modern painting', he was clearly aware of the importance of being in the French capital at that time.[18]

In Edinburgh in 1905, Peploe moved to his third studio in ten years, at 32 York Place. This studio had belonged to the portrait painter, Sir Henry Raeburn, who had worked there for more than twenty years from 1799. The studio, built by Raeburn, had specially enlarged north-facing rear windows and a complex series of shutters which controlled the flow of light into the room. While in his previous studios, Peploe had favoured dark surroundings, he painted the York Place walls a pale pink-grey and covered the floor with polished black linoleum.[19] In these new surroundings Peploe embarked on a series of still lifes and figure paintings which have a far closer affinity with his more spontaneous landscape paintings. In his new works, Peploe emphasised colour harmony and sweeping line at the expense of subject-matter. Whistler's *The Little White Girl: Symphony in White no.2* of 1864 (figure 15) had been shown at the Royal Scottish Academy in 1902 and Peploe took up this Whistlerian theme, producing a series of paintings of women dressed in white and informally posed in the sparsely furnished, brightly lit interior of York Place. In one of the most memorable and resolved works from this period, *Girl in White* (plate 5), the sitter was a professional model, Peggy MacRae. MacRae, who had sat for Roche and who would also sit for Cadell, was described by Stanley Cursiter as having 'the rare gift of complete grace which made her every movement interesting; she dropped naturally into poses which were balanced and harmonious.'[20] Here Peploe shows the posed MacRae as an arrangement of colour and tone, rather than as the objects of figure and sofa that the arrangements of colour and tone might resemble.

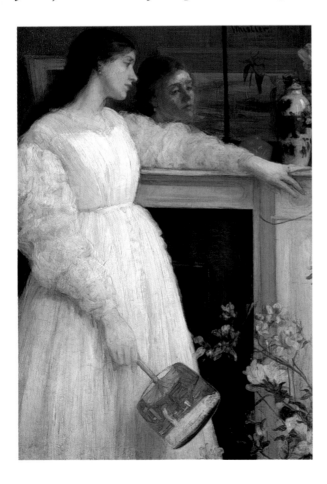

By the time of Fergusson's move to Paris in 1907, he and Peploe had painted together in France on several occasions, favouring the coastal towns and resorts of Dieppe, Etaples and Paris-Plage (figure 16, plates 19, 20, 21). Peploe was with Fergusson in Paris in 1907, when the latter decided to rent a studio in the Boulevard Edgar Quinet.[21] Fergusson's experience of Paris had transformed his work and this must have influenced Peploe's decision to move there in 1910. In the early years of his career Peploe had exhibited on few occasions and always remained reserved in his dealings with galleries. Prior to the opening of his second solo exhibition at Aitken Dott & Son in Edinburgh, held almost six years after his first in 1903, he agreed to accept £450 for the sixty paintings intended for the show. This enabled him to marry Margaret Mackay, whom he had met on Barra many years previously, and finance their move to Paris, where they took a studio-flat at 278 Boulevard Raspail. Peploe was soon introduced to the society that revolved around Fergusson, who by this time had been elected a *Sociétaire* of the Salon d'Automne. Fergusson was delighted to have Peploe's company:

Peploe and I went everywhere together. I took him to see Picasso and he was very much impressed. We went to the Salon d'Automne where we met Bourdelle, Friesz, Pascin and others. He started to send to the Salon d'Automne. I was very happy, for I felt at last he was in a suitable milieu, something more sympathetic than the RSA. He was working hard, and changed from blacks and greys to colour and design.[22]

Peploe's move to Paris and exposure to Fauve painting meant he soon followed Fergusson in developing a more expressionist manner. The small panels which he executed out-of-doors became more densely worked and richer in colour (figure 17). These gave way to paintings with a more balanced synthesis of colour and design, such as *The Luxembourg Gardens* (plate 7). At Royan in 1910, Peploe worked alongside Fergusson, who, by then, had developed a bolder means of expression. In comparison with Peploe's vigorous use of paint (plate 8), Fergusson's views are simplified into large blocks of pure colour (plate 29).

Like many of his contemporaries working in Paris, Fergusson applied his Fauve palette to subject-matter familiar from the nineteenth century; the café society of Toulouse-Lautrec and Degas. The appeal of his less intense portraits of women in elaborate millinery can tend towards nostalgia for the fashion of the period. But at its toughest, as in *Blue Beads, Paris* (figure 37) where the lips are a slash of red, the flesh tones are green and the eyes like coals, his art has a wilful crudity of handling and jarring use of colour which retains its power and immediacy. In 1911 he exhibited *Rhythm* (plate 32) at the Salon d'Automne, which featured a monumental female nude. In his previous work, Fergusson's use of colour had become increasingly decorative and here broad areas are contained by bold outlining. This *cloisonné* effect patterns the whole surface and suppresses space to a minimum. Fergusson's highly stylised, amazon nude holds an apple plucked from the bough behind her in a gesture which equates nature with health. The theme of fecundity was

explored further in *Les Eus* (plate 31), showing a frieze of intertwined dancing male and predominantly female nudes whose dynamic forms are repeated in the surrounding foliage. These ambitious paintings, the largest in the artist's career and arguably his most original works, should be considered in the wider context of Fergusson's Parisian experience. A high-point in the cultural life of this period was the performances of Diaghilev's Ballets Russes, which Fergusson and Peploe attended, and which provided inspiration across all artistic forms. Since the late nineteenth century, dance and music had made a considerable impact on painting. This was especially so in Derain's *La Danse* of c.1906 (figure 46) and Matisse's paintings on the themes of music and dance from 1909 onwards. By 1911, Fergusson's own work had followed a parallel development, moving away from the more overtly expressionist language of Fauvism.

Of the four Colourists, Fergusson was to spend the longest time in Paris, but Cadell and Hunter also had early contact with the city. Hunter is known to have visited Paris soon after 1900, but as has been noted it is difficult to be precise about this or any other date in his early career. Hunter's father's decision to move his family from Rothesay to California in the early 1890s had been made following the premature deaths of two of his children. Hunter remained in America after the return of his family to Scotland, and by 1900 had moved from Los Angeles to San Francisco where he found work illustrating books and magazines.[23] There he was involved in a circle which included the portrait-sculptor Robert Aitken and writers Jack London and Will Irwin. Irwin later wrote the catalogue introduc-

tion for Hunter's 1929 New York exhibition, giving a vivid description of their early bohemian days, a mode of life never entirely abandoned by Hunter. The publication of Hunter's magazine illustrations (figure 18) between 1903 and 1905 in the Glasgow-based *Society Pictorial* (subsequently the *Scots Pictorial*) gives at least an indication that he was working in Scotland in the early years of the new century. At some point during this period he was in Paris, where he was observed busily producing sketches and frequenting the cafés Dôme and Rotonde.[24] His visit may have coincided with the major exhibitions of work by Gauguin and Cézanne held in 1903 and 1904 respectively, but whether they had any immediate effect on his painting is not known. By 1905 Hunter was back in California preparing for his first exhibition. Just prior to its opening in April 1906, San Francisco was struck by an earthquake and all his work was destroyed. He returned to Scotland soon after this catastrophe, and for the next few years based himself at his family's home in Glasgow.

Hunter's early remove to America meant that he was not exposed to the kind of painting that influenced the young Peploe, Fergusson and Cadell. But as an aspiring artist, it is likely Hunter was at least aware of the achievements of the Glasgow Boys whose work was exhibited and publicised extensively in the United States from the mid-1890s onwards. After his return to Scotland in 1906, he hoped to give up illustration and paint full-time. Sales of his paintings were few, however, and he continued to support himself with magazine work, although commissions were evidently no easier to come by. The Scottish artist E.A. Taylor recalled a visit to Hunter in London in the years between 1910 and 1914:

I found him in a little room (I could not call it a studio) in a street off the Tottenham Court Road. A most awful-looking landlady came to the door, and with her naked arms directed me up a flight of narrow stairs to the very top of the house, and there was Hunter. There was hardly room for both of us in the room, which was very untidy. He told me he was busy doing illustrations and covers for Pearson's Magazine, but I never saw the illustrations and

[FIGURE 18]
G.L. Hunter
The Garden Party
illustration from *Society Pictorial*, Glasgow,
11 July 1903
Private collection

[FIGURE 19]
Willem Kalf (1619–1693)
Still Life
Glasgow Museums: Art
Gallery and Museum,
Kelvingrove

[FIGURE 20]
G.L. Hunter
*Fruit and Flowers on a
Draped Table, c.*1919
Lord and Lady Irvine of Lairg
see also plate 40

*rather fancy he had no commission to do them but
was just doing them on chance …*[25]
Hunter also met up with Taylor in Paris, where the
latter had moved in 1910 with his wife the artist,
Jessie M. King. The Taylors were friends with Fer-
gusson and Peploe and according to notes provided
by Hunter for Tom Honeyman, Hunter knew them
there. Hunter recalled that together:
*… they saw everything. They questioned every-
thing, and especially they questioned whatever
seemed to be dogmatic …They questioned the
histories and conclusions upon which they had
been brought up.*[26]
This stirring account of the artists' radical stance
may fit with the contemporary work of Fergusson
and Peploe, but it cannot be said of Hunter's own
painting at this time. In Glasgow, some time after
1910, Hunter had been introduced to Alexander Reid
who acquired a few examples of his work. An exhibi-
tion was subsequently held at Reid's gallery in 1913,
and again in 1916. Press comments were generally
favourable:
*He has three or four examples of still life that are
superlatively strong … they show a mastery of form
and colour that takes one back to the triumphs of
the Dutchmen.*[27]
Interest in Dutch painting was strong among collec-

tors in Glasgow, who were well catered for by deal-
ers such as Reid and Craibe Angus; the latter, in
particular, specialised in this field. The collector,
William Burrell, for example, acquired early Dutch
paintings years before he developed any serious
interest in modern French painting, while works by
seventeenth-century Dutch artists such as Willem
Kalf (figure 19) had been presented to Glasgow's
new museum and art gallery in Kelvingrove Park.
Tom Honeyman (Hunter's biographer), draws
attention to the influences of Chardin, Manet and
Dutch painting, on the basis of reproductions
pasted in the artist's scrapbook, and quotes Hunt-
er's particular admiration of Kalf in the Glasgow
collection.[28] The dates of Hunter's early still-life
paintings can not be stated with any certainty, but
during this period the stylistic influence of Dutch
still life is clear. In these works there is little varia-
tion in Hunter's subject-matter, which is lifted
straight from the Dutch tradition: peeled fruits,
flowers, Chinese porcelain and glassware are
arranged on draped tables set against a dark back-
ground. In these works Hunter's eye is no more
modern than that of Kalf, but precise handling
does gradually give way to a broader, more loaded
brush and skilful manipulation of warm and cool
colours. This is exemplified in *Fruit and Flowers on*

a Draped Table (figure 20, see also plate 40), a painting which belonged to Reid.[29]

As with Peploe ten years earlier, Hunter combined painting patiently pursued still lifes with smaller, more quickly executed panels. The exquisitely crafted *A Peeled Lemon* (plate 39) is more successful for its modest content. The delicately painted *Woman in an Interior* (plate 41) shares an affinity with the *intimiste* work of Vuillard in its unfinished appearance and domestic subject-matter. In 1914 Hunter was at Etaples, producing informal oil sketches of figures, almost candid in their observation (plate 42). Their combination of subject-matter (familiar from the coastal paintings made by Peploe and Fergusson a decade earlier), hot palette and broad massing of figures brings Hunter close to his fellow Colourists. A number of these works were included in his 1916 exhibition, and the review which identified the Dutch tendencies in his painting concluded with the following comments:

It is with his later works that he has taken his courage with both hands. He has pictures titled

'Sur la Plage'. They are dabs of colour, one may say, but the artist knows what he is doing and his arrangement is never at fault. He knows what to leave out, which is the true test.

Cadell went to Paris only a few years after Peploe's first visit in 1894. His family had taken a particular interest in his career and in Paris he was chaperoned by his mother, who was of French extraction (her maiden name was Boileau). There, Cadell alternated between studying at the Académie Julian and painting watercolours and oils out-of-doors, and in his first year he had a watercolour accepted by the Salon. He met the Czech *art nouveau* painter and designer, Alphonse Mucha, and his stay coincided with Bernheim-Jeune's 1901 Van Gogh retrospective.[30] But the works he executed following his return to Edinburgh have little to connect them with the more radical painting he may have seen in France. As well as the portraits and landscapes which he exhibited at the Royal Scottish Academy from 1902, he also painted mythical subjects. Such scenes (figure 21) are exceptional in Cadell's *oeuvre*, though he was later to experiment with allegorical figure compositions.[31] Until around 1909, post-impressionist painting appears to have had little impact upon his work. Rather, his use of rich colour and interest in symbolism is more reminiscent of the work of artists such as Gustave Moreau (who in the 1890s had taught Matisse and Rouault in Paris) and Adolphe Monticelli. Monticelli's painting, in particular, had influenced a number of Scottish artists (including Henry and Hornel) after its inclusion in the Edinburgh International Exhibition in 1886. From 1906 to 1908 Cadell lived in Munich, where the strong symbolist tradition fostered by Franz von Stuck's teaching at the Munich Academy may have made an impression on him. Such works by Cadell, however, can be classified as youthful experiments, and the majority of his early paintings are conventionally handled domestic or outdoor subjects.

In 1909, following the death of his father, Cadell was able to establish himself in a studio in Edinburgh. The work shown in his first exhibition at Aitken Dott & Son late in 1909 demonstrated a cool impressionism similar to that of Peploe, who had exhibited in the same gallery some months before.[32]

[FIGURE 21]
F.C.B. Cadell
Mythical Scene,
c.1907
Scottish National
Gallery of Modern Art,
Edinburgh

[FIGURE 22]
F.C.B. Cadell
St Mark's Square,
Venice, 1910
Private collection

In 1910 Cadell was in Venice, an experience which freed his technique in the same way that landscape painting had relaxed Peploe and Fergusson. Cadell's strongly lit views of the city's landmarks and his 'snapshots' of sophisticated café life are brushed on in loose patterns of strong, pure colour (figure 22), and he continued and modified this approach in subsequent studio paintings. In works such as *Still Life with White Teapot*, *Afternoon* and *The Black Hat* (plates 55, 57, 58), Cadell's subject is modern life, the life of polite society gathered in the grand surroundings of Edinburgh's fashionable Georgian New Town. Cadell worked in a succession of studios in that area, and their stylishly decorated interiors feature prominently in his paintings. He became a popular figure among Edinburgh society, known as much for his flamboyant dress as for his store of *bon mots*. Of the four Colourists, Cadell's art has most often been described in terms of the artist's rich character, described here by Stanley Cursiter:

…careful in dress but seldom without a gay, distinctive note – shepherd tartan trousers – a blue scarf – a yellow waistcoat – or all the glory of his kilt, but with all – an air! … His wit was constant and brilliant – constant, sardonic, Rabelasian or lightly bantering – it was but an indication of many-sided accomplishment which found expression in colour, in verse and life itself.[33]

Whistler too made a deep impression on Cadell:
He was a marvellous painter, the most exquisite of the 'moderns' and he had what some great painters have, a certain 'amateurishness' which I rather like and felt always in Gainsborough. I can best describe what I mean in these words, 'A gentleman painting

for his amusement.' (Of course it must be understood that the said 'gentleman' is a genius as well!)[34] Like Fergusson, Cadell detected an élan in Whistler's character which he emulated in his subsequent painting. Cadell exhibited alongside Whistler's *Symphony in White No.2* (figure 15) at the Academy in Edinburgh in 1902 and there is a very clear affinity in style and pose between that work and Cadell's 1914 *The Black Hat* (figure 24, see also plate 58) and the *c.*1921 *Portrait of a Lady in Black* (plate 61). The latter has all the hallmarks of Cadell's late style: geometric compositions, crisp brushwork, acidic colouring. The earlier work, produced before the First World War, owes a greater debt to the art of Manet and the Impressionists, and this was recognised in contemporary reviews of Cadell's painting, where he was referred to as a 'young impressionist'.[35]

The studied ease which, in retrospect, can be identified in Cadell's work in comparison to the more aggressively modern stance of Fergusson and Peploe does not mean Cadell was a less serious artist. He did not find a ready market for his art, which was criticised for its incoherence and emphasis on colour before form, and his involvement in the foundation of the Edinburgh-based exhibiting group The Society of Eight may have been in part a reaction to the modest sales in his first dealers' exhibitions.[36] The sculptor, James Pittendrigh MacGillivray, was part of Cadell's Edinburgh circle and in 1915 wrote to him of the qualities he perceived in the younger man's painting:
It seems to me more than ever clear that your forte lies in a gift of colour and light – these seen in a joyous mood … I imagine I am right in believing you have something far better and happier to ex-

[FIGURE 23]
S.J. Peploe
Ile de Bréhat, 1911
Scottish National
Gallery of Modern Art,
Edinburgh

opposite:
[FIGURE 24]
F.C.B. Cadell
The Black Hat, 1914
City Art Centre, City of
Edinburgh Museums
and Galleries
See also plate 58

[FIGURE 25]
F.C.B. Cadell
Tommy and the Flapper, 1915
Scottish National Gallery of Modern Art, Edinburgh

[FIGURE 26]
F.C.B. Cadell
Jack and Tommy, 1915
Scottish National Gallery of Modern Art, Edinburgh

press – far more of sun and colour…[37]

By the time Cadell received this encouragement he had begun his friendship with Peploe, who had returned from Paris to Edinburgh in 1912. Peploe had brought with him a group of works to show at Aitken Dott & Son, but these were considered insufficiently commercial and the gallery felt unable to honour its earlier promise of an exhibition.[38] Peploe found an alternative Edinburgh venue, The New Gallery (the premises of The Society of Eight) and his French work was shown there in 1913. The studies he had painted at Ile de Bréhat in 1911 show his approach to landscape had become more disciplined (figure 23). His new still lifes (plates 9, 10) have an awareness of Cubist painting described by the critic of *The Scotsman* in 1913 as 'daringly vivid still life studies with a leaning to Cubism'.[39] These works, with their angled contour lines, hatched brushwork, interplay of objects and shallow picture space, have the devices but none of the abstract qualities of Cubism. The use of flat areas of bright colour, at its most animated in *Tulips and Cup* (plate 9), distances Peploe's work further from the monochromatic austerity of the analytical painting of Picasso and Braque. Since 1900 Peploe had concen-

trated on still life and in these more recent works his experimentation with a new system of representation is at its most radical.

While these still lifes maintain their daring appearance, Peploe understood the limitations of such a systematic approach. In 1918 he wrote to Cadell: 'I am finished with the colour block system that interested me for a long time and await a new development – what it will be I do not yet quite know.'[40] Peploe's war-time letters to Cadell, express frustration with his own art and a despondency which reflected the mood in the country. While Peploe's application to serve had been rejected on health grounds, Cadell spent much of the war in the trenches in France, serving as a private in the Royal Scots Guards before taking a commission as a second lieutenant in the Argyll and Sutherland Highlanders in 1918. Before his posting in 1915 he produced illustrations for a book, *Jack and Tommy* (figures 25, 26), which anticipate the clean lines and flat colour of his work of the 1920s. On his return to Scotland in 1919, he spent the summer recuperating and painting on Iona. Cadell had first visited the island of Iona in 1912, and thereafter returned almost annually (plates 59, 60 and 70). Peploe, who

from 1920 regularly joined Cadell there, understood the invigorating effect the Western Isles had on their art. In one of his letters to Cadell when the latter was invalided in France, Peploe speculated: *…when the war is over I shall go to the Hebrides and recover some vision I have lost. There is something marvellous about the western seas. At Iona – we must all go there next summer.*[41]

During the war period Peploe acted as a point of communication between the four artists. Copies of the magazine *Colour* were sent to Cadell in the trenches, Peploe drawing his attention to a feature showing Fergusson's work. In his letters he mentions a visit from Hunter and describes the latter's 'latest enthusiasm for the Italian primitives'.[42]

During the war Hunter remained in Scotland, working on a relative's farm at Millburn in Lanarkshire. Fergusson spent the period moving between Scotland and London, where in 1915 he had taken a studio in Chelsea, close to the dance school of Margaret Morris. Fergusson and Morris had met in Paris in 1913 and they soon became close. From Antibes in 1914 Fergusson had sent designs for Morris's productions, and with his encouragement she began to draw and paint (figure 27). The social club founded in 1915 by Morris at her studio in Chelsea quickly attracted an artistic circle: Augustus John, Jacob Epstein, Wyndham Lewis, the Sitwells, Arnold Bax, Gordon Craig and Ezra Pound visited, providing Fergusson with the sort of congenial environment which he had enjoyed in Paris.[43] Although not an official war artist, in 1918 Fergusson was engaged on a series of paintings of Portsmouth Docks showing battleships and submarines (plates 33, 34). Fergusson found the imagery of mechanised warfare a rich subject for exploration, but unlike Wyndham Lewis, Paul Nash and C.R.W. Nevinson (whose harsh Futurist war paintings had been shown at The Leicester Galleries in 1916), Fergusson was unable to bring direct experience of the war to his art. In 1918 Fergusson, aged forty-four, underwent a medical to prove his fitness for service, but he was not called up. A close friend during this period was Charles Rennie Mackintosh, whom Fergusson had met before his move to Paris in 1907. Mackintosh and his wife, Margaret Mac-

[FIGURE 27]
Margaret Morris
(1891–1980)
Red Roofs, Dieppe,
c.1922
Scottish National
Gallery of Modern Art,
Edinburgh

donald, had moved away from Glasgow in 1914, settling in London in a studio close to Morris's school. After the war Fergusson and Mackintosh were involved in unsuccessful attempts to reorganise the London Salon of the Independents and in 1920 Mackintosh designed a new dance theatre for Morris, but like the majority of his later plans, this was unrealised.

By 1914, in the space of a few years, Peploe and Fergusson's work had progressed rapidly, placing them in the vanguard of British painters. Fergusson in particular found recognition and received support from the influential critic Frank Rutter, who wrote the introduction to his exhibition at the Doré Galleries in 1914. Cadell and Hunter, by comparison, had yet to establish their reputations, and the history of their development belongs largely to the 1920s. Cadell's work exhibited at The Society of Eight in the first year of the new decade sparked a debate in the *The Scotsman*, following the publication of a letter protesting against his style:
The most hopeless of pessimists will never believe in any widespread acceptance as 'art' of these screaming faces in scarlet, bismuth pink, Reckitt's blue, orange, with perhaps spaces of yellow, in-

opposite:
[FIGURE 28]
F.C.B. Cadell
Detail from
*Interior: the Orange
Blind*, c.1927
Glasgow Museums:
Art Gallery and
Museum, Kelvingrove
See also plate 69

tended to indicate daffodils or tulips, placed in jugs, the 'drawing' of which any Board school child would be ashamed of.[44]

The intensity of colour in Cadell's new work was combined with a handling that distanced these paintings from his earlier impressionistic manner. Abruptly, his style had changed to a more clearly defined technique based on precise, flat brushwork. It is difficult to ascertain what triggered this shift, but his new painting has a zest that fits with the hedonism of the post-war period. The strident colours and bold, angular rhythms give them an unmistakable air of the jazz-age of the 1920s. The lilac-painted walls and black, polished floor of his new studio at 6 Ainslie Place provided a suitable backdrop for his figure compositions and still lifes and his stylishly decorated rooms became the subject of an impressive series of paintings of interiors seen in long perspective. The geometry of these compositions finds frequent relief in the inclusion of elegantly clad figures (*Interior: the Orange Blind*, figure 28, see also plate 69) or casually discarded items

(*The Gold Chair*, plate 62). This interest in the abstract qualities of space, combined with the appeal of fashionable drawing-room life, gives these paintings an affinity with the nineteenth-century work of Sir William Quiller Orchardson, who had excelled in combining Victorian morality with a masterly understanding of the drama of interior space (figure 29). The women in Cadell's 1920s paintings are posed in a similar manner to his previous work, but whereas *The Black Hat* (plate 58) is a more deliberate portrait, the painting of his frequent model Miss Don-Wauchope in *Portrait of a Lady in Black* (plate 61) is highly stylised. Her costume of plain black dress, hat and fan and the understated modelling of face and *décolletage*, reduce her individuality and make her part of his overall compositional scheme. In later paintings on this theme, such as *Lady in Black* (plate 68), the effect can be over-sumptuous, but in *Negro (Pensive)*, one of several male nudes from the period (plate 67), he produced his most daring figure compositions. Cadell is at his most bold in paintings which focus

[FIGURE 29]
**William Quiller
Orchardson**
(1832–1910)
The Rivals, 1883
National Gallery of
Scotland, Edinburgh

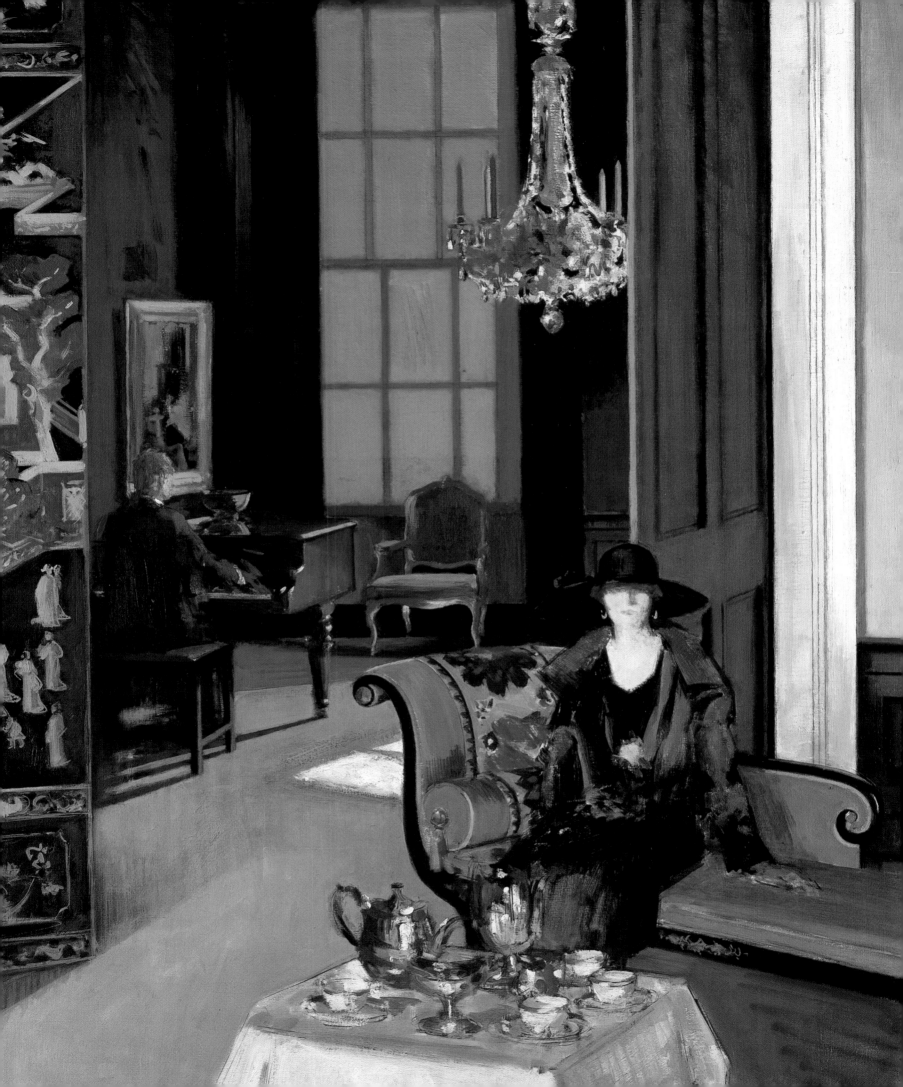

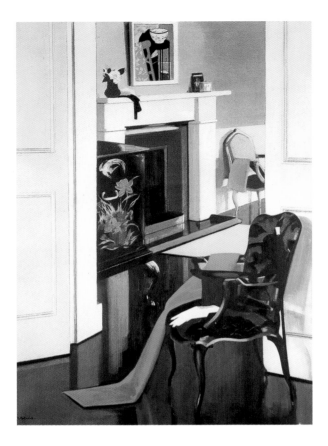

tightly on groups of objects which are stylised to such an extent that the work reads almost as a two-dimensional pattern. In *The Blue Fan* (plate 64) shadows are suppressed to such a degree that the folds of the fan can only be identified by the direction of the artist's carefully measured brushstrokes and by the zig-zag edging, which is thrown into sharp relief by the unmodulated pure red of the chair. These props feature repeatedly in Cadell's paintings of the 1920s, as do his own paintings. *Portrait of a Lady in Black* is shown on the easel in *The Gold Chair.* In *The Opera Hat* (figure 30) the work above the mantelpiece seems to be a version of *The Blue Fan.*

The sharp dissonance of colour that characterises Cadell's studio paintings of the 1920s differs considerably from the cool tonalities of his contemporary work produced on Iona (plate 60). From the 1920s Cadell's visits to Iona were often in the company of Peploe, whose still lifes began to share Cadell's acid colouring. Peploe's *Tulips and Fruit* (figure 31, see also plate 13), for instance, show the close friendship between the two artists during this period. In

June of 1924, the work of all four artists was shown together for the first time, in Paris at the Galerie Barbazanges, where they were referred to as *Les Peintres de l'Ecosse Moderne.* A further exhibition of the four followed in London in 1925 at The Leicester Galleries, with a catalogue introduction by Walter Sickert. This began with an observation on their position in British art:
While Post-Impressionist painters in France have not been inconveniently divided into Fauves and Faux-Fauves, the corresponding division in England may have been said to have been practically established by those licensed by Mr Fry, and those unlicensed by Mr Fry. If this classification be admitted as scientific, the four exhibitors in this room would probably admit, perhaps with regret, that they must fall within this category.[45]
Fergusson, Peploe and Hunter understood, however, the importance of Fry's opinion, Hunter noting in 1922 that they hoped to invite Fry to give one of a number of lectures on modern art the three proposed to hold in Glasgow.[46] By this time Cadell, Peploe and Hunter had attracted a small but loyal clientele. One collector, for example, a Glasgow ship-owner George Service, eventually acquired over 130 works by Cadell. Another ship-owner, Ion Harrison, collected a similar number of works by the four. In the 1930s, when Cadell was often in straitened circumstances, he was welcomed into Harrison's Helensburgh home, visits he subsequently recorded in a number of canvases.

While Cadell, Hunter and Peploe held regular exhibitions in Glasgow and Edinburgh throughout the 1920s, Fergusson remained in London and exhibited less extensively in Scotland. A consequence of this was that his work was not so well collected in Scotland. Nevertheless, he had strong support in his friendship with the Glasgow-based writer John Ressich. Ressich was active in encouraging support for all four artists, often handling sales of Hunter's work when Hunter was in France. A letter from Ressich to Fergusson of 1923 explains Ressich's and Reid's activities which led to the 1924 Paris exhibition, and the beginnings of a wider perception of the four as a group (although in the following only three artists are referred to):

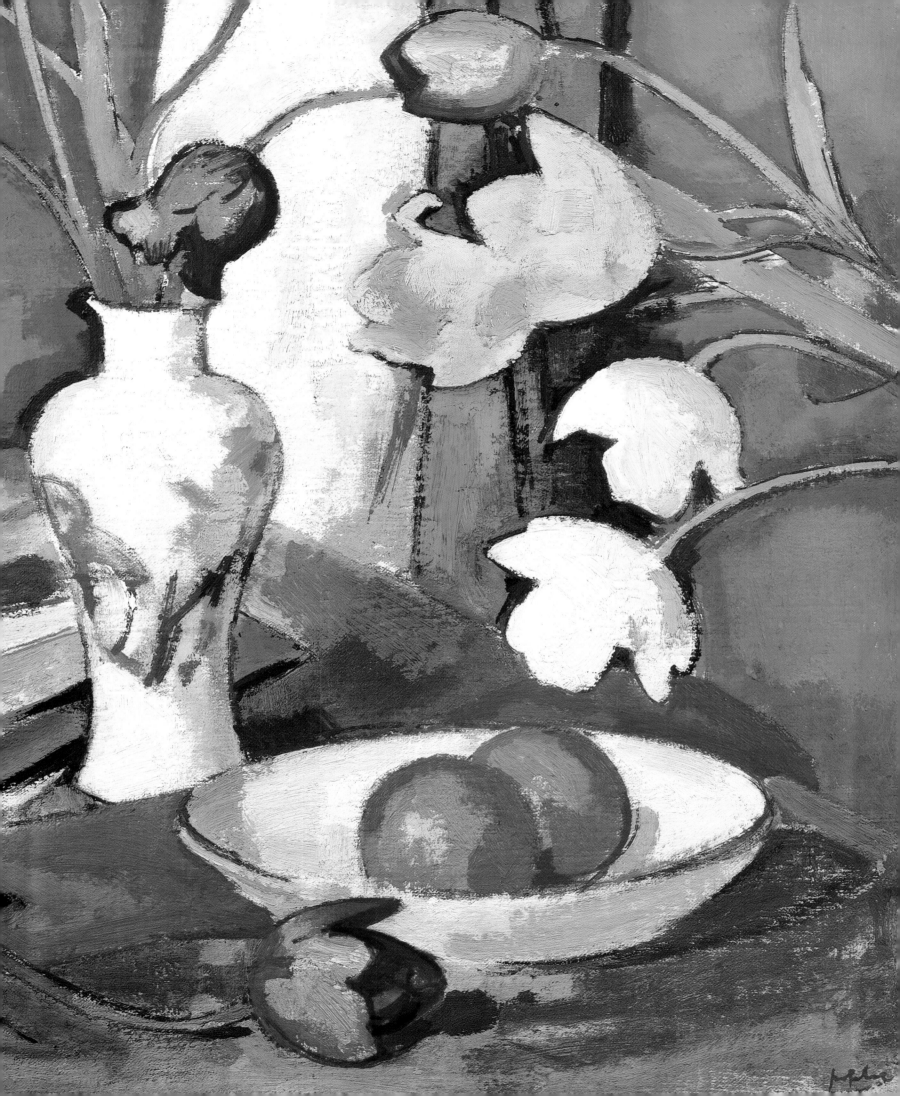

The stage is set – a climax reached. / You would get the 'Herald' following my last two letters. Reid senior, who hitherto has hung back is now definitely FOR the idea of accepting the three of you as a GROUPE ECOSSAIS (his own christening). The local press is agog: all round interest has been created – in short the moment has come – hence my letter in the 'Glasgow Herald'. / Our work is bearing fruit. / Reid senior is back at work full of fight, cursing the Englishman, and more important still – a Paris dealer has just been staying with him. I may not have got his name quite correctly but it is something like Bignon [Bignou], 8 rue de la Boetie, which Hunter tells me is THE street now. He saw your stuff and wants to come in too and has I gather definitely offered to give the combined show in the Barbazanges Gallery, after Dundee and Glasgow, some time between April and July. Twenty pictures of each of you – total 60. [47]

It was with Ressich that Fergusson made an exten-sive tour of Scotland in 1922. Back in London the artist worked intensively for six months, producing a group of around twenty canvases based on the impressions of this trip (plates 35, 36). By this time Fergusson was lodging in a house in Holland Park, the home of George Davison. After the war, Fergusson and Margaret Morris became close friends with Davison (whose wealth had come from the director-ship of Kodak in England) and in the 1920s, Morris's summer-schools were often held in the grounds of Davison's château in the south of France on the Cap d'Antibes. Fergusson frequently joined the school, making sketches in pencil and watercolour (figure 32). In these, his most common motif was figures bathing and resting and this subject was repeated in much of his subsequent work. Fergusson had left behind his expressionist handling in *Rhythm* and *Les Eus*, dating from the early 1910s, and in his ensuing paintings he developed a more openly decorative approach to form which is identifiable

[FIGURE 32]
J.D. Fergusson
La Terrasse, Dinard,
C.1931
Robert Fleming
Holdings Ltd, London

even in his most Fauvist period. While the meaning of the title of *Les Eus* (plate 31) is not clear, Morris noted it was invented by Fergusson to mean 'The Healthy Ones'.[48] Fergusson and Morris strongly identified with the contemporary doctrine that encouraged health through exercise and they frequently photographed each other in exaggerated poses that emphasised their physiques. Much of Fergusson's later work appears to symbolise such vitality, but his use of heavily stylised, interlocking forms, and emphasis on the geometry of figure and landscape can become formulaic. The earlier credo applied to Cadell, 'you have something far better and happier to express – far more of sun and colour', is well communicated in Fergusson's *Christmas Time in the South of France* (plate 37). Such symbolism is realised most effectively, however, not in Fergusson's paintings, but in his powerfully modelled sculpture of the Saxon goddess, *Eástre* (figure 33), cast in brass to represent the 'effect of the sun [and its] triumph … after the gloom of winter'.[49]

While in the 1920s Fergusson, Peploe and Cadell can be said to have adopted a more structured approach to their art, Hunter, conversely, began to paint in a more effusive manner. Post-Impressionist art appears to have affected Hunter only in a minor way early in his career, but a pocket notebook he later carried for addresses and accounts also contains careful notes on Van Gogh, Cézanne and Gauguin and detailed descriptions of the palettes of Cézanne, William MacTaggart and Whistler.[50] Van Gogh is mentioned most extensively; Hunter charts the painter's interest in the techniques of Diaz, Monticelli, Millet and Delacroix before the artist went on to develop a highly individualistic style based on an expressive use of colour.[51] This might be read as a model for Hunter's own progress, whose painting underwent a change after the war from the dark tonalities of his earlier still lifes, to a broad and vigorous use of brightly coloured paint. This development had been anticipated in the studies Hunter had made at Etaples in 1914 (plate 42), and it was in his further landscapes, produced in Fife in around 1919, that this approach took its full hold (plates 43, 44).

Of the four Colourists Hunter took watercolour most seriously, producing numerous works in that medium. In 1924, Alexander Reid had come to a three-year arrangement with Hunter, paying £600 per annum for his pictures. Their subsequent correspondence gives a record of the artist's career during these years when he was moving frequently between Scotland, London and France, in search of subject-matter and particular qualities of light. One letter notes the importance Hunter attributed to his works on paper:

I got your letter and am glad the drawings reached you safely. They are some of a great many I have done. They may seem slight but if you try one or two in white mounts, as I have done here, with white paper behind them, as the paper is thin, you will, I think, find them more solid and substantial, especially at a little distance.

Hunter continues:

[FIGURE 33]
J.D. Fergusson
Eástre (Hymn to the Sun), 1924
Scottish National Gallery of Modern Art, Edinburgh

35

opposite:
[FIGURE 34]
G.L. Hunter
Detail from
Reflections, Balloch,
c.1930
Scottish National
Gallery of Modern Art,
Edinburgh
See also plate 51

Of course my paintings are the main thing. I may stay down here another month or two, and thereby take your advice to finish everything before returning. / I wonder if you could send me another £25 or £30, as buying material for cash here runs off with much. / I had a delightful dinner with Segonzac and some others at Saint-Maxime the other evening. I know the coast now between Monte Carlo and Cassis and have made about a hundred drawings in colour. Fergusson left two days ago. Regards to McInnes, NcNair and Warnock. [52]

Hunter's description of his life in France, and his greetings to collectors of his work, give a picture of the sort of existence he had aspired to from the early 1900s. During the 1920s, however, both his health and his art fluctuated wildly. Intense periods of painting were followed, more than once, by collapse, when he would return to Glasgow to be nursed back to fitness by his sister. Tom Honeyman's biography of Hunter (based on his knowledge of the artist from Honeyman's days when he worked at the amalgamated Reid & Lefevre Gallery) describes several incidents which clearly indicate Hunter's neurotic character. Hunter's work is often of uneven quality, and this may be rationally explained by his deliberate adoption of a more immediate and forcible use of colour. This often resulted in failed or unfinished compositions (plate 54), but in his finest works he brought together rich passages of paint with carefully balanced design. In about 1923 Hunter painted in Venice. On his return to Fife later that year, he expressed disappointment in the conditions he found there, noting that it did not suit his palette as Italy had done. [53] That visit to Italy made him nostalgic for California and he returned to America briefly in 1924. On his return to Scotland he painted at Loch Lomond, and was there again between 1930 and 1931. His paintings of houseboats moored at the water's edge (figure 34, see also plates 51, 52) have an equilibrium of design which he rarely equalled in his other work, prompting Peploe to compare them favourably to Matisse. [54] By 1927 Hunter had moved to the south of France. There, he was based at Saint Paul and also painted at Antibes and Saint Tropez, but failed to produce the oils which were to be exhibited at Reid & Lefevre in London. The resultant exhibition of works on paper did not fair well commercially. However, an exhibition in New York in 1929 improved his confidence. He returned to France following this, and produced oils which have a power derived from his abilities as a graphic artist (plates 49, 50). While there he was taken ill and returned to Scotland. On his recovery he established himself in a new studio in Glasgow in which he executed a series of portraits in 1931. In the same year, his work was shown again in Paris with the other Colourists in an exhibition organised by Reid & Lefevre at the Galerie Georges Petit. One of Hunter's Loch Lomond paintings was acquired by the French state, along with works by Peploe and Fergusson. Hunter had spent much of 1931 in London, where he produced a series of drawings and watercolours of Hyde Park, and he announced plans to move there permanently. But his health continued to fail, and before he could realise his intention to move to London he collapsed and was admitted to hospital in Glasgow for emergency surgery. The treatment came too late and he died immediately afterwards on 7 December 1931. Days before his death, Hunter received word from Fergusson that his painting acquired by the French state had been hung in the Musée du Luxembourg. [55]

The work by Peploe acquired for the Luxembourg was a landscape showing a view at Cassis. Landscape had continued to interest the artist after his return to Scotland in 1912. During the war he painted at Kirkcudbright, and while at first he brought a hot palette to this motif, in subsequent paintings there and elsewhere in Scotland his interest turned to a more structured analysis of his surroundings (plate 12). In the 1920s his landscape painting alternated between Dumfriesshire, Perthshire and Iona in Scotland (plate 11) and in France between Cassis and Antibes, where he was working in 1928 (plate 16). That year he had an exhibition in New York. Peploe supplied biographical notes for the catalogue and although not intended for publication, they were included in the introduction. These brief notes end with a few terse lines describing his professional career:

Took studio in Edinburgh, produced some master-pieces and a lot of failures. Continued like this till 1910 when married; had to work hard. Family appeared – had to work harder still. At that time Paris (1911) a very lively time. Came home again, more family appeared – had to work really hard. This has gone on till present time. / There is no end to Art.[56]
From 1919 Peploe held exhibitions almost every year in Glasgow and Edinburgh. These were dominated by still-life painting, which had formed his principal subject-matter since his return to Scotland prior to the war. While Fergusson's work flourished under the changing circumstances of his surroundings, Peploe was a more introverted character, and found in the motif of still life (painted within the confines of his studio) the ideal means for the development of his art. Rarely venturing beyond a modest cast of flowers, vases, books and fans, he produced numerous works on this subject which allowed him to experiment freely with pictorial composition and circumambient space. He also experimented with different technical approaches, from around 1919 using a white gesso ground which in works such as *Tulips and Fruit* (plate 13) add to the intensity of his colour combinations. These in turn gave way to paintings of a more muted tone, but with a thicker application of paint and a greater monumentality invested in the objects. In contrast to his earlier adoption of a deliberately modern style, these still lifes are remarkably little affected by any other outside influence, although the solidity of form in *Still Life, Roses and Book* (plate 14) shows his understanding of Cézanne. Peploe never tired of painting these works, writing in 1929: 'There is so much in mere objects, flowers, leaves, jugs, what not – colours, forms, relation – I can never see mystery coming to an end.'[57]

Peploe continued working in Edinburgh, and from 1933 taught at Edinburgh College of Art. His failing health meant he had to give up this new responsibility in 1934, and he died on 11 October, 1935. Cadell was deeply upset by the death of his friend and this added to the artist's already somewhat depressed state. While he had been reasonably successful in selling his work in the 1920s, the failure of his 1928 exhibition at Reid & Lefevre signalled a worsening of his fortunes. In the years that followed he consigned large groups of works to auctions and held sales in his studio. Cadell's most loyal collectors had been based in the west of Scotland, and the downturn in the artist's sales must be understood in the context of the depression, which seriously affected Glasgow. Alexander Reid had seen the Scottish art market diminish from the early 1920s, and increasingly his gallery joined forces with The Lefevre Gallery in London. The two amalgamated in 1926 and the Glasgow premises were finally closed in 1932. From 1929 until his death, Cadell moved studio three times, on each occasion to less fashionable areas of the New Town. A series of accidents and illnesses contributed to his deterioration, and he died in Edinburgh on 6 December, 1937. Fergusson, the only survivor of the four artists, had moved back to Paris permanently in 1929, but on the outbreak of the Second World War, returned to Scotland where he and Margaret Morris settled in Glasgow. Very soon they established a new organisation, the New Art Club, which recreated the sort of convivial and free artistic atmosphere which they had thrived on in France and London. The Club gave way to the New Scottish Group, whose exhibitions in Glasgow from 1943 to 1956 provided opportunities for young, independent artists. Fergusson continued to paint, and from 1950 he returned annually to France. He died in Glasgow on 31 January, 1961.

Peploe, Hunter and Cadell were included in the large retrospective of Scottish art held in the Palace of Art at Glasgow's Empire Exhibition in 1938; a version of this was subsequently seen at the Royal Academy in London in 1939. From 1907 until 1939, Fergusson had lived away from Scotland, and while efforts had been made to formalise the grouping of the four artists in the 1920s, Fergusson's continued geographical separation and the fact that he was a living artist, meant he remained a separate entity. In the last twenty years of his career, he was also energetic as a writer, publishing various accounts of the history of modern Scottish painting.[58] Fergusson identified the importance of the Glasgow School as establishing the basis for a tradition in Scottish painting, but considered that Scotland did not recognise its incipient modern movement. Independent

spirits such as William McTaggart who continued to paint with 'freedom and brilliance', however, countered the drift of artists to the south. Fergusson continued:

Younger artists Peploe and Fergusson joined later by Leslie Hunter were formed into a group ... This group, including Cadell, known on the continent as Les Peintres Ecossais kept a contact with the main stream of European painting ...[59]

In his own painting Fergusson saw a formal language of line and pattern whose origins could be found in the linear vocabulary of Celtic art. His own perception of the first stages of Cubism as an exploration of line and form reinforced his view that modernist painting, with its formal interest in structure, could be equated with the rich decorative expression of that northern tradition. In this way Fergusson was able to point to an atavistic relation between modernism and northern culture. He expressed this when describing a portrait of Kathleen Dillon (figure 35):

One day she arrived with a remarkable hat. I said, 'that's a very good hat you've got.' She said 'Yes! isn't it? I've just made it.' It was just like a rose, going from the centre convolution and continuing the 'Rhythm' idea developed in Paris and still with me. Looking at K I soon saw the hat was not merely a hat, but a continuation of the girl's character, her mouth, her nostril, the curl of her hair – her whole character – (feeling of her) like Burns's 'love is like a red red rose. So ... I painted 'Rose Rhythm' – going from the very centre convolutions to her nostril, lips, eyebrows, brooch, buttons, background cushions, right through. At last, this was my statement of something thoroughly Celtic.[60]

Peploe, Hunter and Cadell by comparison were more reticent about their work. Of the four artists, Fergusson remained most closely in tune with modernist developments, and, therefore, was understandably more prone to intellectualise about art. In Paris, Fergusson, and then Peploe, had been dazzled by Fauvist painting and were part of an international community that was voracious in adopting its language. Fergusson's ambitious figure compositions of c.1911–13 and the contemporary still lifes of Peploe, while among their most potent works, sit awkwardly

as part of the *oeuvre* of artists who have been classified as belonging to the tradition of *belle peinture*. Of the four, Fergusson and Peploe were the most radical in their artistic experiments, but none can be said to have been revolutionary in their approach to art. Their early appreciation of continental developments injected a modernist verve into their painting, and in this they were ahead of almost all their British contemporaries. But their work is not really part of the modernist avant garde that begins with Cubism and continues into abstract art and Surrealism, which found a strong following among some English artists from the 1920s onwards. The Colourists' intuitive approach to painting and their rare pictorial gifts was recognised when all four artists were still alive and exhibiting together in Paris in 1931:

The exposition of Scottish painters deserves to be a success because it consists exclusively of 'honest, straightforward work, the expression of an optimistic spirit that is growing more and more rare in modern art as in modern life.[61]

It is the honest, straightforward optimism in the work of the four Scottish Colourists that we should continue to celebrate.

[FIGURE 35]
J.D. Fergusson
Rose Rhythm:
Kathleen Dillon,
1916
Private collection

'Les Peintres de l'Ecosse Moderne': the Colourists and France

ELIZABETH CUMMING

When Herbert Read wrote his survey *Contemporary British Art* in 1951, during the post-war years of austerity, he gave little recognition to the Colourists. Even the revised edition, published in 1964, three years after the death of J.D. Fergusson, was dismissive of the group. He referred only to 'our most northern artists, the Scots, [who] have as a matter of fact been the most slavish followers of French Impressionism and French Fauvism (W. McTaggart, S.J. Peploe, J.D. Ferguson [sic])'.[1] In Read's eyes, Peploe and Fergusson were artists who passively adopted the styles created by their brothers of the auld alliance. This view of an English academic with a modernist agenda contrasted with how they were seen abroad. Dunoyer de Segonzac, for instance, a Parisian painter who had known Fergusson since their days as fellow tutors at the Académie de la Palette before the First World War, referred to the Scot's intense love of life, and how his painting had stood the test of time. Fergusson, he recalled, was 'A great and wholly independent artist who rejected the short-lived formulae of the moment and followed his own path during a long and fine life.'[2] His art was characterised by exceptional colour awareness, by what he called 'Stunning, fresh colours allied to a rich, sumptuous *matière*'. For Segonzac, these painters were international players in the visual arts, yet he emphasised only the decorative properties of Fergusson's art. Exhibitions held in Scotland during the 1970s and 1980s also stressed the sensual colour in the work of the four artists, and located them within the Scottish painterly tradition. Roger Billcliffe also emphasised this national trait in his lavishly illustrated study of 1989, *The Scottish Colourists*.

In the last decade American art historians, in particular, have begun to examine the work of two of the four – Fergusson and Peploe – through their international identity and influence around 1910. This lateral perspective has begun to locate the artists within a cosmopolitan arena. Roberta Tarbell, Carol Nathanson and Mark Antliff have underlined their relationship with American artists, writers and intellectuals in Paris. The gregarious and intellectually inquisitive Fergusson, as the longest resident *artiste imigré* among the Scots and the one who most involved himself in Left Bank cultural politics has been well-documented. In particular, Tarbell has examined the lives of two of his former pupils at La Palette, Marguerite Thompson and her future husband William Zorach.[3] Nathanson's pioneering work on Anne Estelle Rice, Fergusson's partner from 1907 until 1913, has catalogued their personal lives, work and intellectual relationships from a foreign perspective.[4] In perhaps the most challenging study, Antliff has demonstrated Fergusson's role in amplifying the theories of the philosopher Henri Bergson in 1910–11.[5]

The introduction to the artistic culture of France for both Peploe and Fergusson was through familiarity with not only the Glasgow Boys but also the Barbizon School whose work could be seen in the galleries of Glasgow and Edinburgh in the 1890s. In the tradition of Scots artists, they both headed for France in search of galleries, formal training and artists' studios. There were, of course, many Paris attractions for artists by the late 1890s – the gallery run by Durand-Ruel and, far from least, the Caillebotte Bequest, on view at the Palais du Luxembourg

[FIGURE 36]
S.J. Peploe
The Luxembourg Gardens, c.1910
Robert Fleming Holdings Ltd, London
see also plate 7

41

since 1897, where good work by Manet, Monet, Sisley and Pissarro was on display. Fergusson later recalled the impression made on each by these modern painters: 'Manet and Monet were the painters who fixed our direction, in Peploe's case Manet especially … I was daft about painting and had given up the idea of medicine to devote myself entirely to it.'[6] According to Fergusson, Peploe had already read Moore's *Modern Painting* and Zola's *L'Oeuvre*. In its subject-matter, rich tonal values and thick impasto, the work by Peploe and Fergusson from this time is informed not only by the modern French artists but also by Velázquez and Whistler. Subsequent visits in the late 1890s to Paris, were to confirm the direction each was to follow in his art. In search of light and colour effects, Fergusson also visited North Africa in 1899 and Spain in 1901. Paris, however, remained their Mecca, a city in which art theory was being formulated and life pleasurable. Of the two, it was already Fergusson who more eagerly immersed himself in French culture, reading poetry and, with an interest in correspondences between art and music, enjoying the very sound of the language: '… at that time I was very interested in French poetry and claimed that without knowing French thoroughly I could get a great deal out of Gautier's *Emaux et Camées*, merely as a sound composition of words …'.[7]

Certainly by 1900 the two men had met, and over the next five years had shared ambitions: their small-scale, intimate and intensely-realised oils were intuitive responses to their subjects and showed continuing observance of both Dutch and French traditions. Still lifes of fruit, flowers, books, glass and silver, even shellfish were executed with an impressionistic swiftness. By the mid-1900s their styles were drawing apart, Peploe was engaging in 'white period' large-scale free figure studies in which his colour range expanded and the looseness of his brushwork became even more pronounced. Such paintings as *Girl in White* (plate 5) is both a modern re-evaluation of a Scots empiricist style of painting and a spectacular celebration of Whistler's portrayal of feminine identity.

Peploe, more than Fergusson at this date, was anxious to build up a professional practice in Scot-land, but, while maintaining various links with their native country, both artists enjoyed exhibitions in London in the years between 1905 and 1910. As a new professional, Fergusson laid out his manifesto in the catalogue introduction for his 1905 show at the Baillie Gallery. In it, he showed how he was committed to both impressionist and post-impressionist theory. He was 'trying for truth, for reality; through light … for form and colour which are the painter's only means of representing life, exist only on account of light' but he also believed that art was 'purely a matter of emotion, sincerity in art consists of being faithful to one's emotions … to restrain an emotion is to kill it…'.[8] This shows him starting to engage intellectually with the expressive rawness of Fauvism which was to impact on his oils later that year.

The post-1905 years saw all four Colourists pursuing their art in differing ways within an international arena. From 1904 Peploe and Fergusson had painted *en plein air* together in Brittany – resorts such as Etretat, Etaples, Dunkirk, Berneval and Le Tréport. Leslie Hunter's brief career as an illustrator in San Francisco came to a sudden end with the earthquake of April 1906. Abandoning the city of Frank Norris's *McTeague* he came to London via Glasgow, visiting Paris as means permitted. Despite losing an entire exhibition of work to the earthquake, Hunter did not change direction, and his graphic work remained the base of his art for the rest of his career, informing much of his painting in its relationship of tone, colour and form. While there is no absolute evidence that Hunter met either Peploe or Fergusson in Paris, the existence of seven Fergusson drypoints which may be dated to about late 1906–7 may document an early friendship between the two largely self-taught Scots.[9] Cadell aged sixteen had already exhibited a watercolour at the 1899 Paris Salon and on Arthur Melville's advice studied at the Académie Julian from 1900–3. In 1906 he moved with his family to Munich where he remained for two years.

Fergusson finally committed himself to moving to Paris in the summer of 1907 after meeting the American illustrator Anne Estelle Rice on his annual visit to the resort of Paris-Plage by Le Touquet. Rice had

come to Paris in late 1905 to provide illustrations for a fashion commentary by Elizabeth Dryden for a Philadelphia newspaper, *The North American*, owned by the son of John Wanamaker, proprietor of that city's principal department store.[10] A cameo of the relationship between Fergusson and Rice was provided by the American writer Theodore Dreiser in his short story 'Ellen Adams Wrynn' from *A Gallery of Women* (1929).[11] Wrynn (or Rice) enjoys a satisfying intellectual and emotional relationship with the Scottish artist, Keir McKail, which benefits her art, and their affair ends when McKail abandons her for a young dancer. (This parallels Fergusson leaving Rice for the English dancer Margaret Morris in 1913.) They have separate studios near each other in Montparnasse but operate a 'double ménage' in which 'some of his belongings … were here and … some of hers there … sometimes breakfast was eaten there, sometimes here'.[12] The character of McKail is a caricature of the early twentieth-century Scot, a 'short, stocky, strong, defiant even … your glen and heather Scotchman: broad-shouldered, a most determined and forceful man of about thirty-five or forty … careless … of his dress and the general effect his manner might produce … silent, recessive, subdued'.[13] In reality, Fergusson was neat in his dress and his 'big, white studio, high up on Montparnasse' which the English critic Holbrook Jackson visited in 1909, had an atmosphere of 'almost scientific cleanliness'.[14]

From his arrival in Paris, Fergusson launched himself into artistic society, helping establish a group of like-minded intellectuals and artists.[15] Fergusson and Rice, with Peploe from the time of the latter's settling in Paris in the summer of 1910, were at the centre of a group of artists, writers and poets who met in the cafés of Montparnasse. Apart from Dryden, American members of the group included the sculptor Jo Davidson, poet and dramatist Horace Holley, and painters Jerome Blum and Bertha Case: others who formed part of the circle were Hall Ruffy, an Irish poet, the critic Hannen Swaffer, an aviator and mathematician called La Torrie, Louis de Kerstratt and his sister Yvonne (married to Davidson from 1909) and, also from 1910, the Scots illustrator and designer Jessie M.

King and her husband, designer E.A. Taylor. Rice formed the subject of the majority of Fergusson's female studies in the period 1907–10 but he also used Bertha Case as the model for *The Pink Parasol* of 1908 (Glasgow Museums: Art Gallery and Museum, Kelvingrove) and Yvonne Davidson for *The Blue Hat, Closerie des Lilas* (plate 28).

From 1907 to 1912 Fergusson exhibited annually at the vast Salon d'Automne in the Grand Palais, becoming a *Sociétaire* in 1909 and serving on the hanging jury from 1911. Rice showed at the Salon from 1908 until 1913 and was elected a *Sociétaire* in 1910, serving on the jury in 1912.[16] In 1907 the open submission included more than 571 exhibitors and 1,748 works on view. Among the displays were the Cézanne memorial exhibition, a selection of Rodin drawings and retrospectives of the work of Berthe Morisot and Eva Gonzales. But perhaps of most interest to Fergusson were the works of Henri Matisse, who, with Albert Marquet, served as a juror. Matisse's study for *Music* and the painting *Le Luxe I*, both from that year, were exhibited as 'sketches'. The concept of art as fundamentally expression, and that intellectual relationship between colour and line – which eventually led Matisse to declare that expression was 'one and the same thing as decoration' – made Fergusson look hard at issues of representation. Writing in 1945, Fergusson recalled how the expression 'the logic of line' meant something in Paris 'that it couldn't mean in Edinburgh'.[17] Rice was also to consider the meaning of line. Writing in 1912 on the current Ballets Russes productions, she referred to 'analysis of linear structure' which pervaded the arts : everyone, she said was searching for 'living lines'.[18] Again, in Dreiser's tale, Wrynn's friend tells the narrator that McKail has 'almost forgotten the existence of the old stuff in this really new field already, and yet he painted in that manner for fifteen years. He can't even mention those earlier fellows in this line – Monet, Manet, Degas, Renoir, and that crowd – without cursing. And even Cézanne, Gauguin, and Van Gogh are old masters as compared, for instance and for him, to Matisse, Picasso, Van Dongen and a few others. He considers Matisse the last word as to line, Picasso as a colourist.'[19] The elemental meaning of line as both expres-

of 1904–7 (plates 19–23) lack the raw directness of this work. Fergusson at this stage supported Matisse's ideal of art as emotive expression.

It has been pointed out how the French Fauve artists generally were 'coming to terms in 1907 with Cézanne, whose solidified forms and figures provided a powerful counterforce to the Fauve Palette'.[21] As they were moving away from the relative immediacy of sensory expressionism towards a more conceptual meaning in their art, so too the group around Fergusson – Rice, Peploe and the students of La Palette – gradually redefined their adopted Fauvist principles. From 1907 to 1909 Fergusson produced a series of oils in which he experimented increasingly with relationships of planes, surface pattern and the intellectual dimension of his subjects. Many of these, but not all, are portraits of women and often feature Rice. Among these, *Le Manteau Chinois* of 1909 (plate 27) is at once Whistlerian and modern in its echo of Matisse's study of his wife in *La Japonaise au bord de l'eau* of 1905. The direct *Portrait of Anne Estelle Rice* (plate 25), *The Blue Hat, Closerie des Lilas* (plate 28) and the later *Blue Beads, Paris* (figure 37) are all rich dialogues between colours and planes and they deal with definitions of identity.

In this period, Fergusson also celebrates and reflects the variety of Parisian visual culture. The bold *La Terrasse, Café d'Harcourt* of c.1908–9 (plate 26), which illustrates an evening scene in a local café-bar bustling with 'petites filles', uses the darkness of night to bring the figures into a lamplit frieze across the foreground.[22] In a direct reference to Parisian graphic design, specifically the gendered imagery and scale of the poster, a woman in shocking pink in the foreground faces the viewer straight on. Represented in two-dimensional terms, her mask expression and roughly painted skirt indicate she is a symbol of contemporary popular culture. Her *en face* position also indicates her sexual availability, and that of her female associates. The colour of her dress and hat, also symbols of her sexuality, is repeated in the roses also worn by all the other female café customers. Most of these girls were milliners and their flowered hats are depicted as tokens of identity. Finally, the painted surface is

sion and a definition of creativity develops through Fergusson's oils of 1908–11, culminating in the canvas *Rhythm* (plate 32) which Fergusson showed at the Salon d'Automne in 1911.

The work and theory of Matisse and Cézanne, together with ideas generated by members of his new café society, provided the stimulus for Fergusson's artistic development over a four-year period from 1907. Initially he was more attracted to Matisse's sense of colour than the artist's use of line as elemental form. An early study of Rice, painted outside one of the cafés they frequented (plate 24) was conceived as a close-up snapshot. Referring to Matisse's 1905 portrait of his wife, Fergusson uses a bright green for the hat's shadow as well as bold, flat areas of blue and blue-black, all blocked in with swift, wide brushstrokes.[20] The painting has a directness and wholeness lacking in much of his earlier work in Paris: his larger Whistlerian *Dieppe, 14 July 1905: Night* (plate 21), and his quick studies of street and beach scenes in Paris and Paris-Plage

united through its powerful decorative arrangement of colours ranging from yellows and mint greens through lilacs to this shrill pink with its sexual symbolism.[23]

In this scene of the Café d'Harcourt, the colours are intensified, as in poster art, by the use of flat areas of rich, dark blacks. Fergusson and Rice experimented in these years with ways of defining colours within a painting: how should colours be placed side by side, and what sort of edge should lie between them? Both used hatching techniques in their oils and came to adopt a *cloissoniste* technique, although far removed from that of the Post-Impressionists. For the Scot, inspiration came from the paintings of Auguste Chabaud (figure 38), a Fauve artist who also showed at the Salon d'Automne and who had been singled out by Fergusson in an important review of the 1909 exhibition he wrote for Frank Rutter's *Art News*. Fergusson used his review to celebrate the empathetic Fauve aesthetic in which the 'Matisseites ... insist on expressing themselves frankly and fearlessly' in contrast to the Whistlerian 'materialistic point of view'.[24]

Chabaud, an artist and poet, celebrated scenes of Parisian daily life, the elements of each scene boldly defined in thick, dark paint. He said that he took his inspiration from daily experience.[25] His impact on the group was certainly first seen in Fergusson's work in black edging and the use of what the critic Claude Roger-Marx called a 'Chabaud blue'. Only after 1911 did such vital definition shape the work of Peploe. E.A. Taylor, more a friend of Peploe than Fergusson, later wrote to T.J. Honeyman of Peploe's interest in Chabaud's lines, 'very strong stuff, thick thick lines and flat colours'.[26] For Rice and Fergusson, however, defining colour through linear containment opened up further possibilities. Both began to edge their colours in blue or red contours, sometimes using them in combination. In Rice's fine *Self-portrait* (figure 39), probably executed in 1910 and displayed prominently in the Salon d'Automne that year, a fruitbowl, flowers and her own portrait (as a portrait within the painting a definition of interiority) are all contained by a red line.[27] The device is repeated in *La Toilette* of 1910–

left:
[FIGURE 38]
Auguste Chabaud
(1882–1955)
*Le Moulin Rouge,
la nuit,* 1907–8
Petit Palais, Musée
d'art moderne, Genève

above:
[FIGURE 39]
Anne Estelle Rice
(1878–1959)
Self-portrait,
c.1909–10
Private collection

11 (figure 40), a modern Matissesque classical pose, and in Royan landscapes by both Rice and Fergusson from 1910.

Experiments in using blocks of colour beside each other and in defining outline also informed the teaching at the Académie de la Palette. The students in Fergusson's group included the Canadian Emily Carr, the English artist Jessica Dismorr, and the Americans Marguerite Thompson and William Zorach. When Zorach, a lithographer from Cleveland, Ohio, arrived as a student in March 1911, he found Thompson painting 'a pink and yellow nude with a bold blue outline'.[28] That this was by then standard practice at La Palette is demonstrated by Thompson's oils of 1910 including her figurative *Rites of Spring: Olympian Offerings* (figure 41) and her landscape *Les Baux, Moonlight* (Whitney Museum of American Art, New York). Her later work in tapestry translated her expressive art practice into a craft format. By late 1912 Zorach was home in Cleveland and his own work (figure 42) was to be at least as decorative, although still more Post-Impressionist than Fauve in its romantic decorative qualities. Zorach wrote in his autobiography that in Paris he 'could not accept Matisse's distortions or the poster look of his paintings, but found his color and freedom exciting'.[29]

Peploe, resident with his wife and new family in Paris from 1910 to 1912, also found the high-key emotionalism and freedom of Fauvist painting (seen by some as either a broad and simplistic or an unclear aesthetic) extremely attractive. To say that his landscapes of *c*.1910 simply explore and indicate the play of light on local colour and form, might suggest that he was a reserved Scot (which he was), overly conscious of future sales at home in Edinburgh[30] and not wishing to stray too far from impressionist ideals. In fact, his work at this date was free, with looser, almost wild, brushwork than he was to use again. Paintings such as *Street Scene, France*, *The Luxembourg Gardens*, and *Boats at Royan* (plates 6, 7, 8) reflect the colour notations found in the work of Othon Friesz. Friesz was the only member of the inner Fauve circle who was particularly well known to the Scots through the Salon d'Automne. He shared a studio with Bouguereau and together with the sculptor Emile Antoine Bourdelle they frequented the Dôme café at the crossing of the Boulevards Montparnasse and Raspail. It seems entirely likely that it was through Friesz that Fergusson came into contact with the poets Paul Fort and Guillaume Apollinaire who also frequented the Closerie des Lilas on the corner of the Boulevards Montparnasse and Saint-Michel.[31] Jean Metzinger (like Chabaud a painter-poet) not only also taught at La Palette, but also attended the weekly meetings held by Fort at the Closerie. Fergusson, himself deeply interested in the relationships of literature, poetry and music, would have valued their company.

The attraction of Friesz for Peploe was not just his social connections but the economical way he painted with rhythmic, isolated lines of colour. He was a mural decorator, who provided wall decorations for the international exhibitions in Paris in both 1900 and 1937, as well as an easel artist. His paintings of La Ciotat, on the Côte d'Azur, where he had spent the summer of 1907 with Georges Braque, had been shown at the Salon d'Automne. In these, controlled colour notation indicated a planar understanding of the landscape. Friesz was consciously intellectualising his whole process of painting the

46

land, combining, even replacing, the optical with the essentially conceptual. The process for Friesz was more than simply an analysis of the landscape in volumetric terms. As Marcel Giry and René Jullian wrote in the catalogue of his memorial exhibition in 1953, between 1910 and 1912 Friesz 'constructed the landscape in terms of volume and organised it according to rhythm'.[32]

It is feasible also to consider that Friesz by 1912 was himself responding to ideas formulated by the Fergusson group as Fergusson, Rice, and to a lesser extent Peploe, developed the whole concept of 'rhythm' as an inclusive philosophy equally applicable to music, art and language. Peploe's still lifes of 1912–13 (plates 9, 10), while maintaining the vibrancy of the landscape oils of the previous two years, are 'rhythmist' in their increasingly tightened formal control. He, like so many others in Paris, was interested in the legacy of Cézanne and the cubist theory of his Closerie acquaintance, Jean Metzinger.

Underlying the Rhythmists' theory lay the philosophy of Henri Bergson. From accounts provided by both Fergusson and his friend, the English writer John Middleton Murry, we know that they were both devotees of Bergson's work by the time they met in Paris, according to Murry, at the Café d'Harcourt in late 1910. Murry, then an Oxford undergraduate, had come over to read Bergson in the French philosopher's own city. He also saw Post-Impressionist art (also on show that year in London at Roger Fry's first exhibition at the Grafton Gallery) at first hand, writing home that the 'yellow greens screamed in a discord which was the consummation of a perfect harmony'.[33] According to Murry, when he met Fergusson he was immediately taken with the Scot's 'rakish bowler-hat, his blue collar, his keen shaven face, and his fresh bowtie' and described Rice as a 'buxom and charming woman, with a fresh complexion, and smiling eyes of periwinkle blue'.[34] The men shared Bergson's understanding of 'the intrinsic harmony and unity of nature'. As a result, *Rhythm*, the Bergsonian arts journal they founded, was first published in London in the summer of 1911 with Murry as editor and Fergusson's design on the cover.[35] As *Rhythm*'s art editor until November 1912, Fergusson commissioned work from artists with whom he was already in touch – Derain, De Segonzac, Herbin, Friesz, Gaudier-Brzeska and Picasso as well as Rice and Peploe (figure 44).[36]

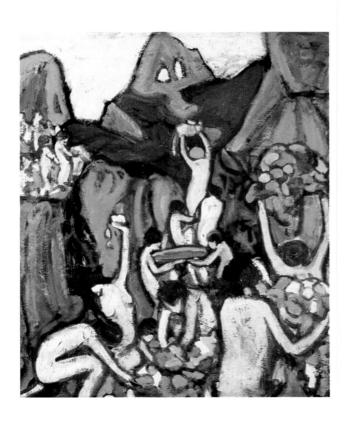

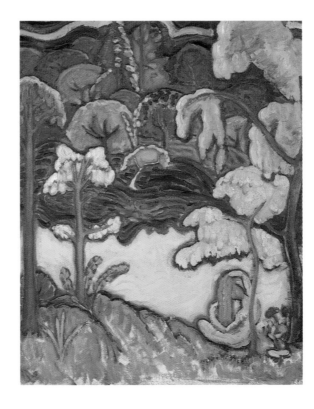

[FIGURE 41]
Marguerite Thompson Zorach (1889–1968)
Rites of Spring – Olympian Offerings, 1909
Jack S. Blanton Museum of Art, The University of Texas at Austin, Texas, purchased through the generosity of Mari and James A. Michener, 1985

[FIGURE 42]
William Zorach (1889–1966)
Woods in Autumn, 1913
Whitney Museum of American Art, New York, gift of an anonymous donor

47

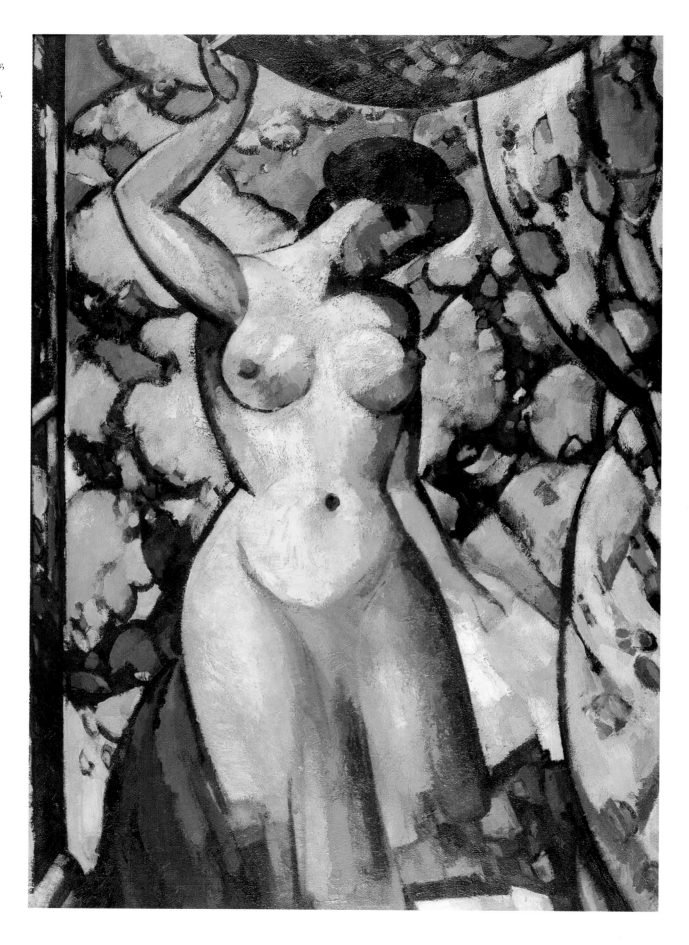

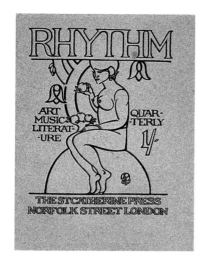

[FIGURE 44, A, B, C]

Rhythm, vol. 1, no. 1,
The St Catherine Press,
London, 1911
Lord and Lady Macfarlane
of Bearsden

left to right:

J.D. Fergusson
Cover design

S.J. Peploe
*Gate of the Luxembourg
Gardens*

Anne Estelle Rice
Schéhérazade

The word 'rhythm' for Fergusson meant the essence of life, realised in an intense moment of insight by the artist. It was found in all the arts. As Murry recalled:

… for Fergusson it was the essential quality in a painting or sculpture; and since it was at that moment that the Russian Ballet first came to Western Europe for a season at the Châtelet, dancing was obviously linked, by rhythm, with the plastic arts. From that it was but a short step to the position that rhythm was the distinctive element in all the arts, and that the real purpose of this 'modern movement' … was to reassert the pre-eminence of rhythm.[37]

We know from 'Memories of Peploe', Fergusson's sketchbook references and, not least, illustrations chosen for *Rhythm*, that he and Rice (permitted free tickets as *Sociétaires*) and also Peploe, Jessica Dismorr and 'Georges' Banks attended Diaghilev's various Ballets Russes productions including *Schéhérazade*, *Petrushka*, *Salomé*, and *La Spectre de la Rose*. In order to establish an even fuller cultural synthesis in *Rhythm*, Tristan Derème and Francis Carco, two of the leading Parisian *poètes fantaisistes* known throughout café society, were persuaded to contribute: in 1913 Fergusson, De Segonzac and Rice supplied illustrations to Carco's *Chansons aigres-douces*.[38]

Derain and Matisse towards the end of their true 'Fauve' periods (1905–7) were reviewing and acknowledging the figure as central to their intellectual stance and moving in their imagery from a harmoni-ous towards a dynamic relationship between individual and setting.[39] Matisse, in particular, was reconsidering the formal values established by Cézanne, partly informed by the memorial display at the 1907 Salon d'Automne. The subsequent performances of the Ballets Russes from 1909 also impacted deeply on Parisian art. Music, theatre and art came together to establish a truly exhilarating cultural symbiosis. In these dance performances, the relationship of the figures to the coloured and patterned sets, the primordial choreography and the sounds conjoined in a new harmony of strange, exotic form and content quite outside traditional European experience. An extraordinary world in which primitivism was allied to sophistication had come to Paris.

These factors, as much as the impetus provided by the new literary circles in which Fergusson and Rice moved, were to inform their own new figurative art of 1910–12. In this, each was working out a visual definition of rhythm, of relationship of parts to establish a Bergsonian totality of vision. The imagery in all these works is depersonalised, and, as Mark Antliff has noted, this helped focus their 'spiritual rather than their corporeal status'.[40] Importantly, Carol Nathanson has established that an associate of the Rhythmist group, Horace Holley (who, as director of the Ashnur Gallery in Paris in 1912–14, supported the painters) was a student of the Baha'i faith, with its code of transcendence of material reality, and author of *Baha'ism: the Modern Social Religion* published in 1913.[41] Paintings of 1910 and early 1911 such as *La Bête violette* (plate 30) and

Voiles indiennes (University of Stirling), look to Matisse in their decorative expression, but they also present a union of eastern and western cultures through imagery and composition.

Even greater synthesis was achieved in a remarkable series of nudes which include *At my Studio Window* of 1910 (figure 43) and *Rhythm* of 1911 (plate 32). *Rhythm* may be viewed, of course, in the context of both the figured pastoral landscapes of both Derain and Matisse. The female figure in *Rhythm* may be read as a Ceres, goddess of nature, or as Eve, seated in front of the tree of life.[42] The critic, Hunter Carter, wrote at the time of the work's 'strong, decided line' which for him expressed a 'great elemental truth, namely there is a line of

continuity underlying life which has bound all Eves ever since the world began'.[43] She is a powerful icon of fecundity, illustrative of the strengths of creation and creativity. In terms of context, she needs to be seen alongside the sculpture of *Maternity* of 1910–11 (figure 45) by Jacob Epstein. Indeed, in Fergusson's own account of his Paris days, Epstein emerges as a friend from at least 1912 when he visited him seeking help to prevent censorship of his Oscar Wilde tomb sculpture in Père Lachaise cemetery.[44] *Maternity* is as monumentally primitive as Matisse's bronze series *The Backs* (1909–30). It presents the ultimate figure of fruitful pregnancy with greatly swollen belly and breasts. Fergusson uses similar full breasts in *Rhythm* (and, to a lesser extent, *At my Studio Window*) and, again in common with Epstein's figure, closed eyes (a motif repeatedly used in other paintings in 1910 and 1911) which both removes the figure from open dialogue with the viewer and reflects Fergusson's interest in Indian art.[45]

The massive oil painting *Les Eus* of *c.*1911–13 (plate 31) further explores the concept of primitivism but now through dance, pattern and colour it is the climax of Fergusson's visual realisation of Bergson's *élan vital*. It examines the concept of earthly paradise and depicts the energy of life. Derain's exotic canvas *La Danse* (figure 46) of *c.*1906, with its memories of Indian decorative forms, may also have been at the back of Fergusson's mind. Matisse's own *La Danse* had been shown at the 1910 Salon d'Automne, and Fergusson similarly desires to compress the physical energy of the large figures into the confines of his canvas. In *Les Eus* (which Fergusson is said to have called 'The Healthy Ones'),[46] nude dancers occupy and identify with a dense decorative jungle landscape, their free, rhythmic actions reflecting the performances of Isadora Duncan and the theories of Emile Jacques-Dalcroze. Jacques-Dalcroze's institute, established in Hellerau in October 1911, emphasised the relationship between dance and health, and his published theories, known as 'eurhythmics', were published at the same date. The English translation of the following year included an essay on 'The Value of Eurhythmics to Art' by Murry's friend, Michael Sadler. Fergusson used this current theory both to name his painting

[FIGURE 46]
André Derain
(1880–1954)
*La Danse, c.*1906
Fondation Fridart
© DACS 2000

and iconographically to emphasise the holistic nature of his subject. Both book and painting pre-date the Ballets Russes performances of Stravinsky's *The Rite of Spring* (1913).

In 1912, the year of Fry's second Post-Impressionist exhibition, Huntly Carter's book *The New Spirit in Drama and Art* was published in London. Carter, already supportive in 1911 of the group's work through his reviews in the London journal, *The New Age*, devoted space to the Rhythmists, referring to the 'rhythmical music' of a Rice portrait of *c.*1910–11, *Nicoline*.[47] He defined the purpose of 'a good picture' (which *Nicoline* was) to be 'not merely to illuminate the soul of the subject-matter, but to lift the spectator out of himself, to link him with the universal'.[48] In the same year, 1912, Fergusson organised a display of the Rhythmists' work in Cologne at the international Kunstausstellung des Sonderbundes. Among paintings sent were Rice's decorative and brightly coloured *The Egyptian Dancers* and Fergus-

son's nudes *Torse de Femme, La Force* and *At my Studio Window*, all works from 1910. In 1912, also, the Peploes decided to return to Edinburgh. By 1913, with Fergusson's withdrawal as art editor of *Rhythm*, the group had splintered.

A new phase in the Colourists' careers was opening up, with each artist working essentially independently but their common traits of colour and compositional flair gradually becoming known at home in Scotland and in France. In the summer of 1911 Peploe had painted on the Ile de Bréhat and at Cassis to the west of La Ciotat, exploring colour and light in the landscape. In this, of course, he was consciously following in the steps of the French Fauves: since 1905 Matisse, Derain, Marquet and Manguin had all painted in the south. In 1907, Friesz had spent the summer with Braque at La Ciotat, visiting Derain at Cassis and returning in 1910. Not surprisingly, therefore, the Scots were drawn to the Côte d'Azur. Peploe returned to Cassis

with Fergusson in 1913 in a party that included Rice and the English writer, Raymond Drey, whom she was to marry in December. The oil paintings they produced are formalised and impose the energetic linearity of the Paris work onto the organised colours of land and shadows. In their rigorous structuralism, they differ radically from the French artists' earlier work. The same attitude may be seen in Peploe's still lifes of 1912 and 1913 (plates 9 and 10). The latter were called 'cubist' in *The Studio* in 1914, perhaps because of their linear angularity, their broadly hatched technique and their lack of shadowing, but no work by Peploe, or indeed Fergusson, even begins to uncover cubist theory. The most dynamic of these still lifes is Peploe's study of a bottle, jug, cup, bowl and rose (plate 10). This is a composition of angularity and rhythm, beautifully composed with the pictorial arrangement balanced by a geometricised background. Just how sharply Peploe uses line and colour here may be seen when compared with an equally careful but more colour-based work from the war years, his *Interior with Japanese Print* of c.1916 (figure 47).

From this time work began to be seen increasingly outside Scotland and Paris. In 1912 both Peploe and Fergusson had solo shows, plus a joint one, at the Stafford Gallery in London. In the following year *Rhythm* was included in the exhibition of Post-Impressionist and Futurist art organised by Frank Rutter at the Doré Galleries, also in London. By September Fergusson had moved from Cassis to Cap d'Antibes where he settled, coming north to London with Margaret Morris only after the outbreak of war. As the Scots Parisians came to adopt the *Midi* as a second home, so Hunter and Cadell were rethinking the values of paint. In 1914 Hunter was painting at Etaples (plate 42), where his quick sketches have a *faux naïf* freshness of vision. By this date the Glasgow dealer Alexander Reid was buying from him for his West George Street gallery, La Société des Beaux-Arts, and introduced his work to a number of Scottish collectors.[49] Reid was a celebrated dealer who handled work by Sisley, Monet, Pissarro and Degas at the turn of the century, and who is nowadays best known for his friendship as a young man with Theo and Vincent van Gogh in the

late 1880s while working for Boussod and Valadon in Paris.[50] He was also a man who was soon to become a key figure in establishing the collective identity of the Colourist group. In 1916 he gave Hunter an exhibition at which the 'dabs of colour' produced at Etaples were admired for their faultless arrangement and control. Colours were arranged in a largely intuitive manner, without obvious reference to the work of his peers. To his loyal collectors over the next two decades his work, as Roger Billcliffe has pointed out, could equal the work of the French moderns: William McInnes, for instance, 'might buy a Matisse one week and a Hunter the next'.[51] Hunter moved from small sketches to more ambitious canvases, but always representational and always landscape. From all accounts, he appears to have been a restless man, searching on his travels for colour and light, much as an Impressionist might.

Cadell also travelled in Europe. In 1910 he visited Florence and Venice where the startling light effects helped establish colour codes for subsequent work from still-life sketches to portraiture. His use of white as background colour in his portraits of Edinburgh society women announced the age of modernism. It was also used as a Whistlerian form of decorative empathetic representation of the sitter – similar in fact to Fergusson's use of a Chinese coat or a coloured shawl in his Edwardian portraits. But like the other three it was to France he went in search of culture, colour and climate. During the early 1920s the artists' travels went hand-in-hand with a series of exhibitions held at home as increasingly dealers and clients looked for work. In 1923, for instance, Fergusson's solo show at Aitken Dott & Son in Edinburgh transferred to Reid's Gallery in Glasgow. The same year Cadell, Hunter and Peploe were all shown together in an exhibition at The Leicester Galleries in London and Hunter travelled to Paris, Florence and Venice, comparing and skilfully capturing the impact of light on his environment.

As was the case for French artists such as Dufy and Matisse, light repeatedly drew the Scottish painters back to the *Midi* during the 1920s. Part of the attraction was the presence not only of Fergusson in Cap d'Antibes but also the French 'colourists'

[FIGURE 47]
S.J. Peploe
Interior with Japanese Print,
c.1916
University of Hull Art Collection, Humberside

themselves. Matisse was resident in Nice as well as Paris, and from 1922 Dufy was also dividing his time between Paris and the south. As a result of regular 'refresher' visits to the Côte d'Azur through this decade, French attitude was absorbed into the identity of each artist, infusing their work with new colour, tonal values and use of line. The colour inherent in the landscape affected the Scots in different ways. When Cadell painted in Cassis with Peploe in 1924 (as he was to do again in 1928) he produced strong, semi-abstracted views of the town (plate 65) in which form and shadow are marked out equally in flat colour areas, very much in a 'French' style. Hunter too felt the impact of southern art: in *Juan-les-Pins* of *c*.1927 (plate 45), the combination of quick ink drawing and areas of spontaneous colour recall the fresh vitality of work by Dufy. This was precisely the kind of work to which the next two generations of Scottish artists would aspire.

The international gallery network that supported the four was led by Alexander Reid. In 1923, as well as showing Fergusson at his Société des Beaux-Arts, Reid was also instrumental in setting up the London exhibition for the other three at The Leicester Galleries. In the summer of 1924, finally, all four artists were shown together in Paris at the Galerie Barbazanges under the title of 'Les Peintres de l'Ecosse Moderne'. To the French, they were ambassadors of Scottish art, and reviews, as a friend of Hunter was to recall, commented on the 'force and purity of their colour' which 'attracted sensational attention'.[52] In 1931 they were joined by fellow Scots G. Telfer Bear and R.O. Dunlop for an exhibition at the Galerie Georges Petit. But Paris was not the only international city to see their work. In 1928 both Peploe and Fergusson had one-man shows at the New York gallery run by C.W. Kraushaar which had shown work by the American Rhythmists (today the Kraushaar Gallery on Fifth Avenue still maintains that interest). As his American dealer, Kraushaar organised a show of Fergusson's sculpture at the Arts Club of Chicago the following year and in 1929, Hunter was exhibited by the Ferargil Galleries in New York.

Members of the group, and increasingly they were identified as such, were international players.

Their travels infused their work with a sense of decorative vibrancy that contrasts with the Scottish landscapes of Peploe and Cadell in particular. In Cadell's case, the experience of the new French visual culture informed his work to a remarkable extent. In his paintings of the interior of his own home of the late 1920s, the figures become compositional icons of modernity. The identity of the image is that of art deco sophistication translated into a Scottish idiom. Cadell bought furniture for his flat in Ainslie Place from the firm of Whytock & Reid. The company is known for its quality craftsmanship: in the period 1890 to 1918 it produced work for the Arts and Crafts architect Sir Robert Lorimer. In the mid-1920s its products were 'increasingly sought after by people of judgment and taste'.[53] Cadell's paintings of this time, including *Interior: the Orange Blind* (plate 69) are often labelled as images of Edinburgh drawingrooms, which of course they are, but as representational images and colour compositions they also reflect the artist's awareness of a French style aesthetic transferred to Scotland. Cadell painted the rooms in contemporary colours and, while never looking to replace the traditional classicism of his Edinburgh interior with the style of the modern movement, Cadell demonstrated his visual sophistication through colour, space and figurative details. His art illustrates modern dress set in a representation of a neoclassical interior totally modernised through colour – the correlation of the fashionable style of 1925 Paris with its new 'moderne' brand of classicism. But through colour applied to the interior he showed his awareness of French taste most of all: the way he combined acid oranges and yellows and emerald greens, mixed with glossy black would not have surprised designers such as Jean Dunand or Henri Rapin.

Without their French contacts and experience, none of the Scottish Colourists would have developed their art as we know it. For all, visiting and living in France invested their ideas with a new vision. For Cadell, it meant developing an empathy with stylistic sophistication. For Hunter, visiting the south of France especially injected a light airiness into his landscapes. For Peploe, two years of life in Paris opened a door to the intellectual possibilities

within traditional subjects. And for Fergusson, living in France for far longer than any of the others, it became the crux of his existence. When he settled in Chelsea during the First World War he established, with Margaret Morris, a club culture which had its roots in Parisian café society. Its members included John Galsworthy, G. Lowes Dickinson, Gilbert Murray, Charles Rennie Mackintosh and Margaret Mackintosh, Eugéne Goosens, Cyril Scott, Constant Lambert, Augustus John, Ezra Pound and Ethel Smyth. The same was true of his life in Glasgow after 1939 when he set up the New Art Club. Fergusson wanted to invest his corner of each city with Parisian-style culture, its accessibility, vitality and intellectual bite: often, and especially latterly in Glasgow, he must have been disappointed. But as an active contributor to that extraordinary early twentieth-century Parisian exchange between cultures, he helped achieve an internationalism which reached from France to America.

S. J. PEPLOE
1871–1935

'To step from Sir James Guthrie's room
in Burlington House into Peploe's room
… has the effect of stepping from fog and
murk into sunshine and air.'

HERBERT FURST
Editor of *Apollo*, 1939

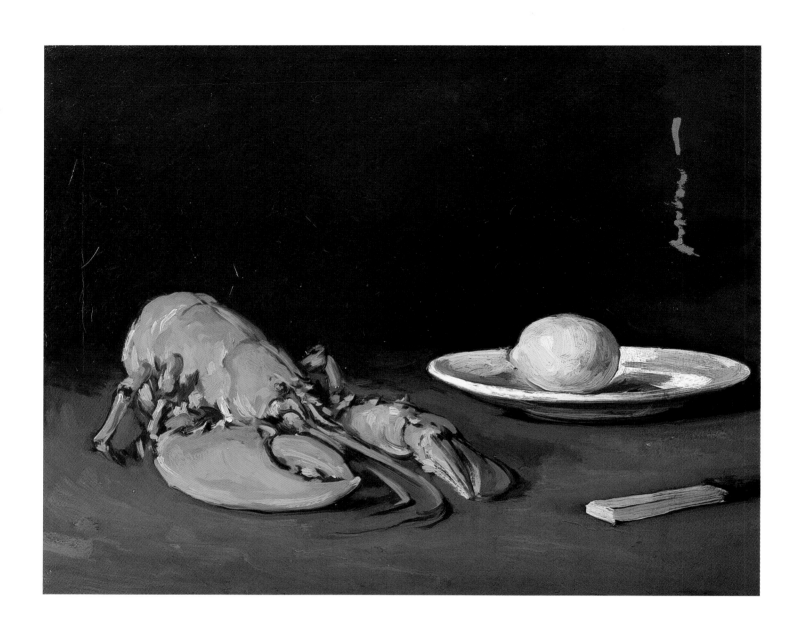

[PLATE 1]
S.J. Peploe *The Lobster*, c.1903
Oil on canvas, 40.7 × 50.8
Private collection

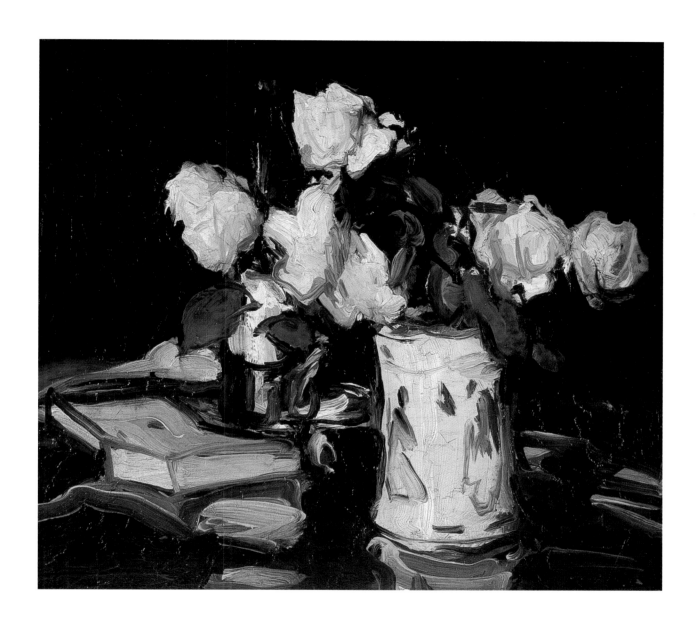

[PLATE 2]
S.J. Peploe *Roses in a Blue and White Vase, Black Background*, c.1904
Oil on canvas, 40.6 × 45.5
Private collection

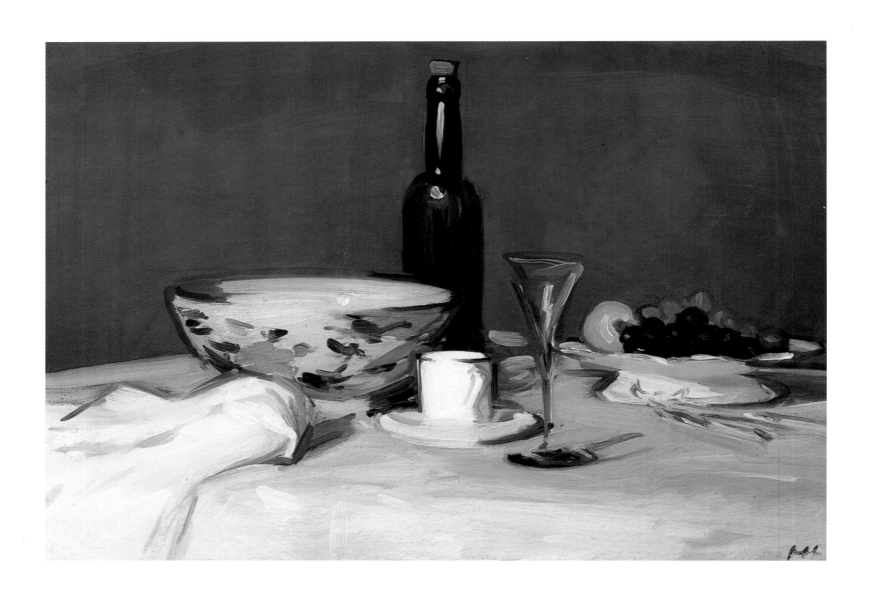

[PLATE 3]
S.J. Peploe *The Black Bottle*, c.1905
Oil on canvas, 50.8 × 76.2
Private collection

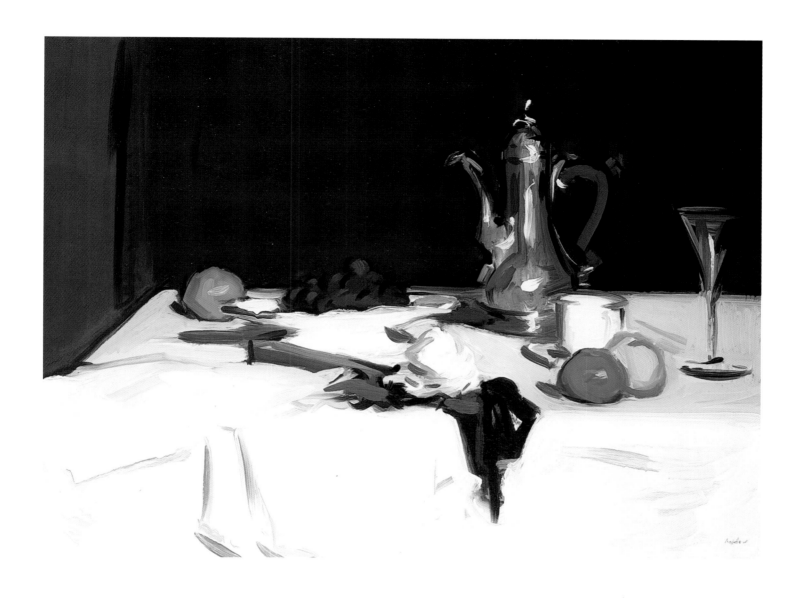

[PLATE 4]
S.J. Peploe *Still Life with Coffee Pot, c.*1905
Oil on canvas, 61 × 82.5
Private collection, courtesy The Fine Art Society, London

[PLATE 5] *opposite*
S.J. Peploe *Girl in White*, 1907
Oil on canvas, 84.5 × 61.5
Private collection

[PLATE 6]
S.J. Peploe *Street Scene, France, c.*1910
Oil on canvas, 34 × 26.5
Private collection

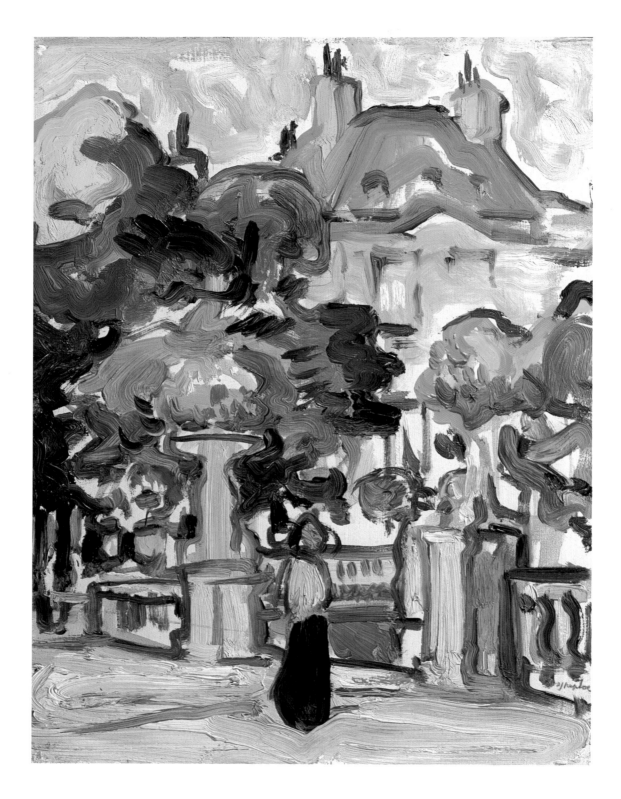

[PLATE 7]
S.J. Peploe *The Luxembourg Gardens,* c.1910
Oil on panel, 35.5 × 28
Robert Fleming Holdings Ltd, London

[PLATE 8]
S.J. Peploe *Boats at Royan,* 1910
Oil on board, 29 × 33
Lord and Lady Irvine of Lairg

[PLATE 9]
S.J. Peploe *Tulips and Cup, c.1912*
Oil on canvas, 45.6 × 40.6
Hunterian Art Gallery, University of Glasgow
(bequeathed by George Smith 1997)

[PLATE 10]
S.J. Peploe *Still Life*, c.1913
Oil on canvas, 55 × 46
Scottish National Gallery of Modern Art
(presented by A.J. McNeill Reid 1946)

[PLATE 11]
S.J. Peploe *Green Sea, Iona, c.1920*
Oil on canvas, 50.8 × 60.9
Robert Fleming Holdings Ltd, London

[PLATE 12]
S.J. Peploe *Kirkcudbright, c.1919*
Oil on canvas, 55.9 × 63.5
Robert Fleming Holdings Ltd, London

[PLATE 13]

S.J. Peploe *Tulips and Fruit, c.1919*
Oil on canvas, 58 × 48
Private collection

[PLATE 14]
S.J. Peploe *Still Life, Roses and Book*, c.1920
Oil on canvas, 73.7 × 60
Private collection

[PLATE 15]

S.J. Peploe *Landscape at Cassis*, 1924
Oil on canvas, 55.6 × 45.7
Scottish National Gallery of Modern Art
(bequeathed by Mr Gordon Binnie: received 1963)

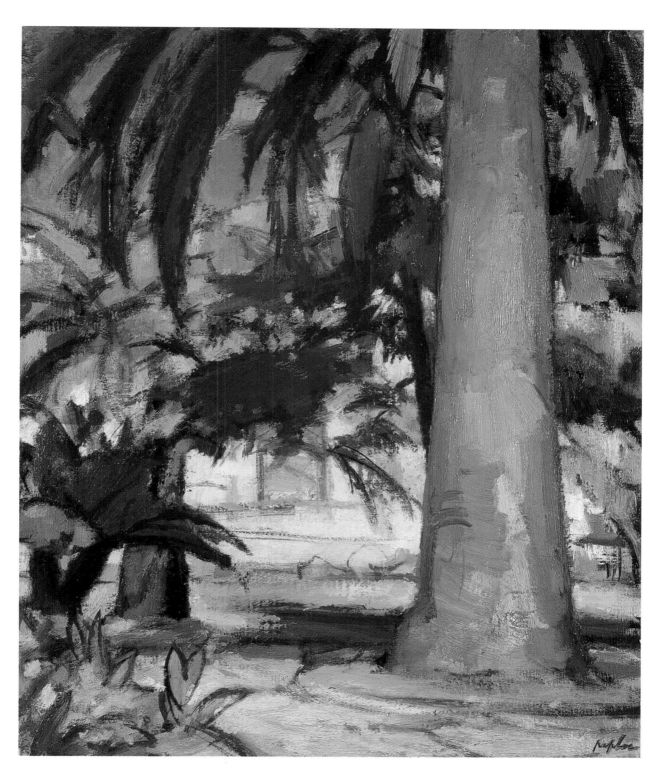

[PLATE 16]
S.J. Peploe *Palm Trees, Antibes,* 1928
Oil on canvas, 61.5 × 51.5
Fife Council Museums:
Kirkcaldy Museum and Art Gallery (purchased 1964)

J. D. FERGUSSON
1874–1961

'His art is a deep and pure expression of his
immense love of life. Capable of achieving a rare,
almost sculptural quality, he also adds an exceptional
sense of colour: loud and vibrant colour uniting
with his rich and sumptuous subjects.'

ANDRÉ DUNOYER DE SEGONZAC
Painter, 1961

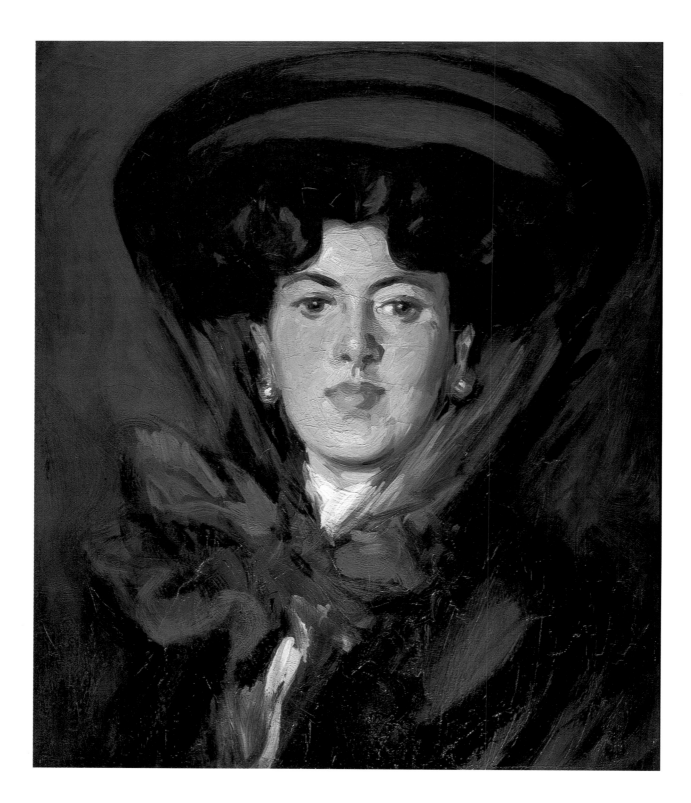

[PLATE 17]
J.D. Fergusson *Jean Maconochie*, c.1902
Oil on canvas, 60.9 × 50.8
Robert Fleming Holdings Ltd, London

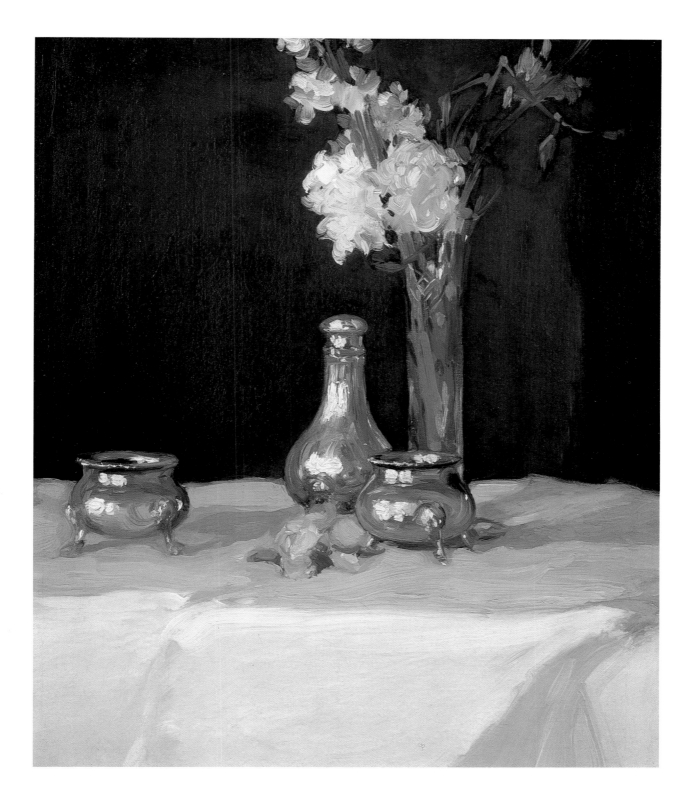

[PLATE 18]
J.D. Fergusson *Jonquils and Silver*, 1905
Oil on canvas, 49 × 43
Robert Fleming Holdings Ltd, London

[PLATE 19]
J.D. Fergusson *Grey Day, Paris-Plage*, 1905
Oil on canvas, 35.6 × 45.7
Glasgow Museums: Art Gallery and Museum, Kelvingrove (Hamilton Bequest 1981)

[PLATE 20]
J.D. Fergusson *In Paris-Plage, Night,* 1904
Oil on board, 18.9 × 23.9
Private collection

[PLATE 21]
J.D. Fergusson *Dieppe, 14 July 1905: Night*, 1905
Oil on canvas, 76.5 × 76.5
Scottish National Gallery of Modern Art (purchased 1978)

J.D. Fergusson *Pont des Arts, Paris,* 1907
Oil on board, 19 × 24
Lord and Lady Macfarlane of Bearsden

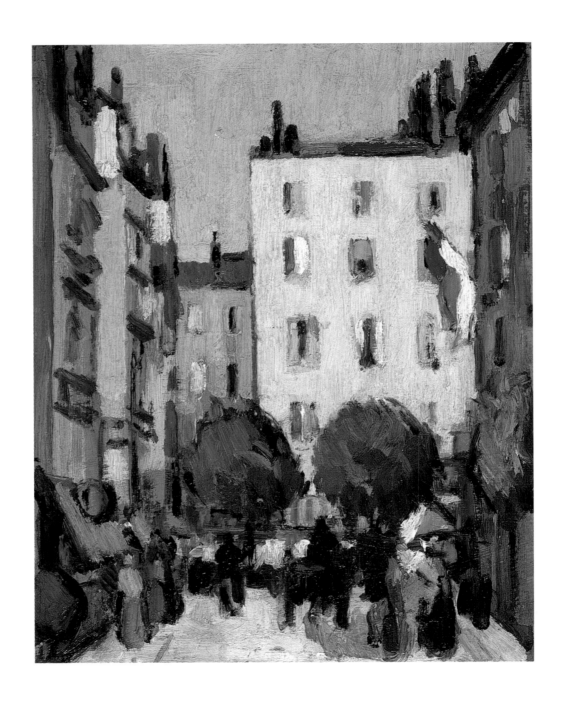

[PLATE 23]
J.D. Fergusson *Paris*, 1907
Oil on board, 35 × 27.5
Private collection

[PLATE 24]
J.D. Fergusson *Closerie des Lilas,* 1907
Oil on panel, 27 × 34
Hunterian Art Gallery, University of Glasgow
(acquired by exchange 1967)

J.D. Fergusson *Portrait of Anne Estelle Rice*, 1908
Oil on board, 66.5 × 57.5
Scottish National Gallery of Modern Art (purchased 1971)

[PLATE 26]
J.D. Fergusson *La Terrasse, Café d'Harcourt*, c.1908–9
Oil on canvas, 108.6 × 122
Private collection

[PLATE 27] *opposite*
J.D. Fergusson
Le Manteau Chinois, 1909
Oil on canvas, 200 × 96.5
The Fergusson Gallery, Perth and Kinross Council
(presented by the J.D. Fergusson Art Foundation 1991)

[PLATE 28]
J.D. Fergusson *The Blue Hat,*
Closerie des Lilas, 1909
Oil on canvas, 76.2 × 76.2
City Art Centre, City of Edinburgh
Museums and Galleries (purchased 1962)

[PLATE 29]
J.D. Fergusson *Royan*, 1910
Oil on board, 27 × 35
Hunterian Art Gallery, University of Glasgow
(bequeathed by Gilbert Innes 1971)

[PLATE 30]
J.D. Fergusson *La Bête violette*, 1910
Oil on canvas, 77.5 × 77.5
Lord and Lady Irvine of Lairg

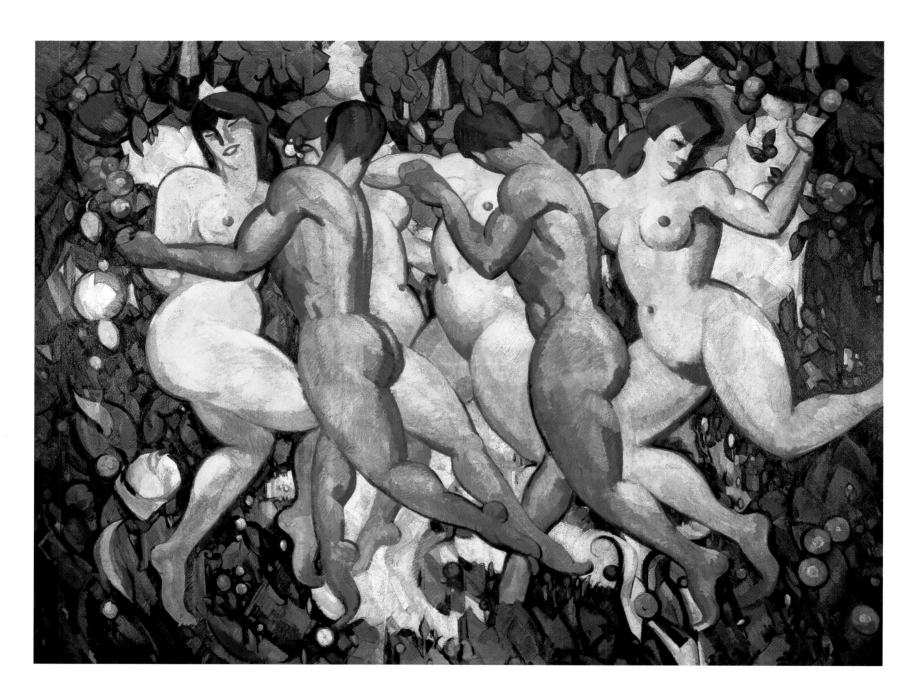

[PLATE 31]
J.D. Fergusson *Les Eus*, *c.*1911–13
Oil on canvas, 213.3 × 274.3
Hunterian Art Gallery, University of Glasgow
(presented by the J.D. Fergusson Art Foundation 1990)

[PLATE 32] *opposite*
J.D. Fergusson *Rhythm*, 1911
Oil on canvas, 162.6 × 114.6
University of Stirling J.D. Fergusson Memorial Collection

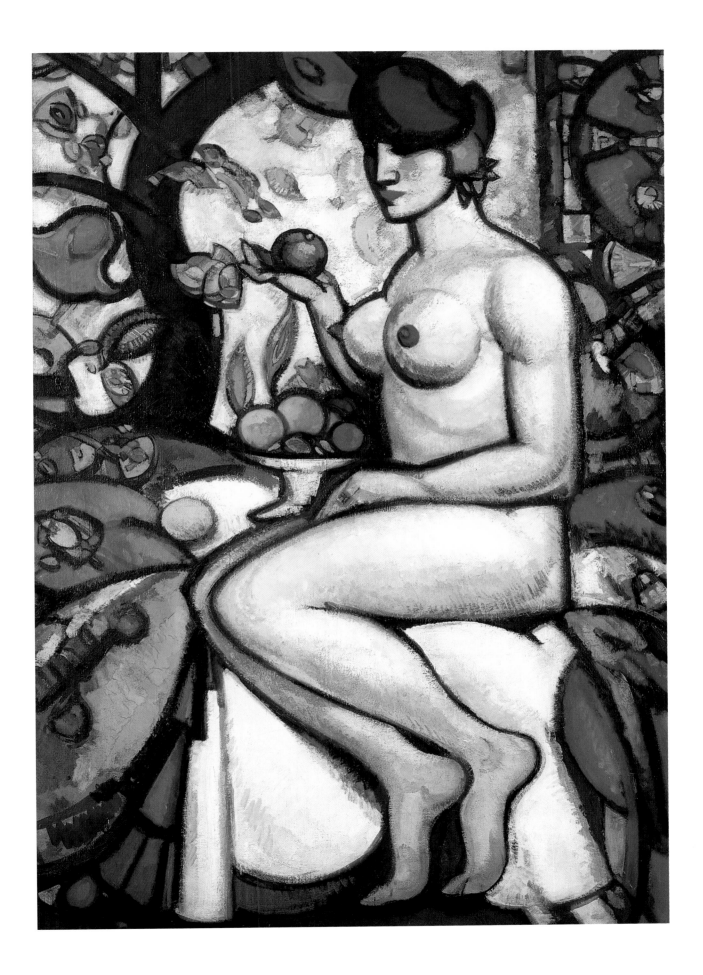

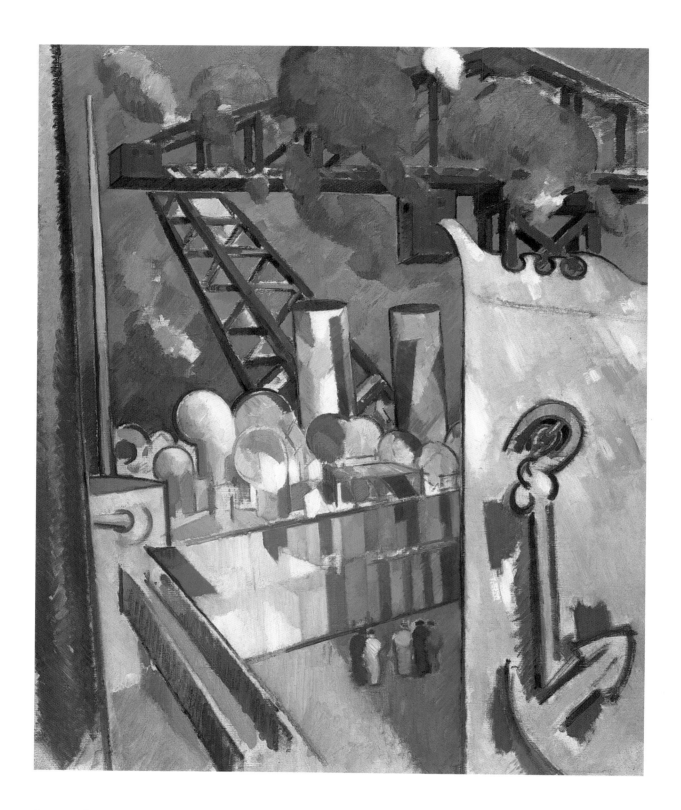

[PLATE 33]
J.D. Fergusson *Portsmouth Docks*, 1918
Oil on canvas, 92 × 73
University of Stirling J.D. Fergusson Memorial Collection

[PLATE 34]
J.D. Fergusson *Damaged Destroyer*, 1918
Oil on canvas, 73.6 × 76.2
Glasgow Museums: Art Gallery and Museum, Kelvingrove
(presented by Glasgow Art Gallery and Museums Association 1976)

[PLATE 35]
J.D. Fergusson *A Puff of Smoke near Milngavie*, 1922
Oil on canvas, 56 × 61
Lord and Lady Macfarlane of Bearsden

[PLATE 36]
J.D. Fergusson *In Glen Isla*, 1922/3
Oil on canvas, 56 × 61
University of Stirling J.D. Fergusson Memorial Collection

[PLATE 37]

J.D. Fergusson *Christmas Time in the South of France*, c.1922
Oil on canvas, 61 × 55.8
The Fergusson Gallery, Perth and Kinross Council
(purchased with assistance from the Heritage Lottery Fund 1998)

[PLATE 38]
J.D. Fergusson *The Log Cabin Houseboat*, 1925
Oil on canvas, 76.2 × 66
Scottish National Gallery of Modern Art (purchased 1966)

G.L. HUNTER
1877–1931

'Leslie Hunter, with his heart singing a high note, dashing at his canvas in impetuous haste, eager to capture the quivering thought while it still glowed.'

STANLEY CURSITER
Gallery director and artist, 1951

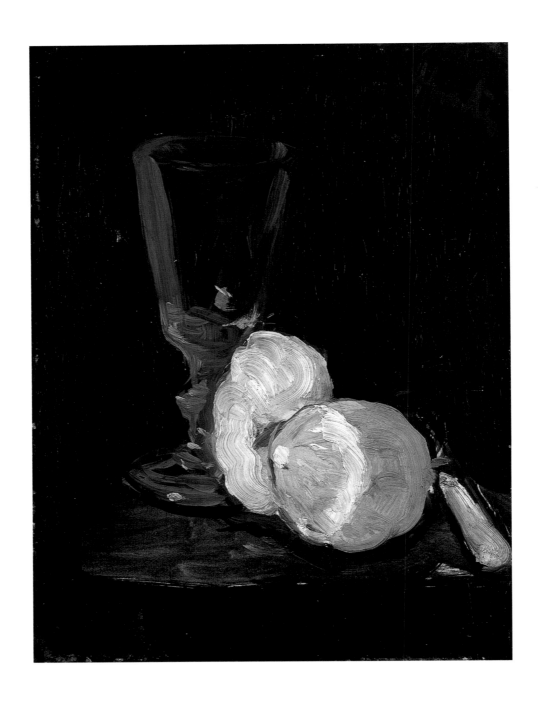

[PLATE 39]
G.L. Hunter *A Peeled Lemon*, c.1913
Oil on board, 30.9 × 23.1
Private collection

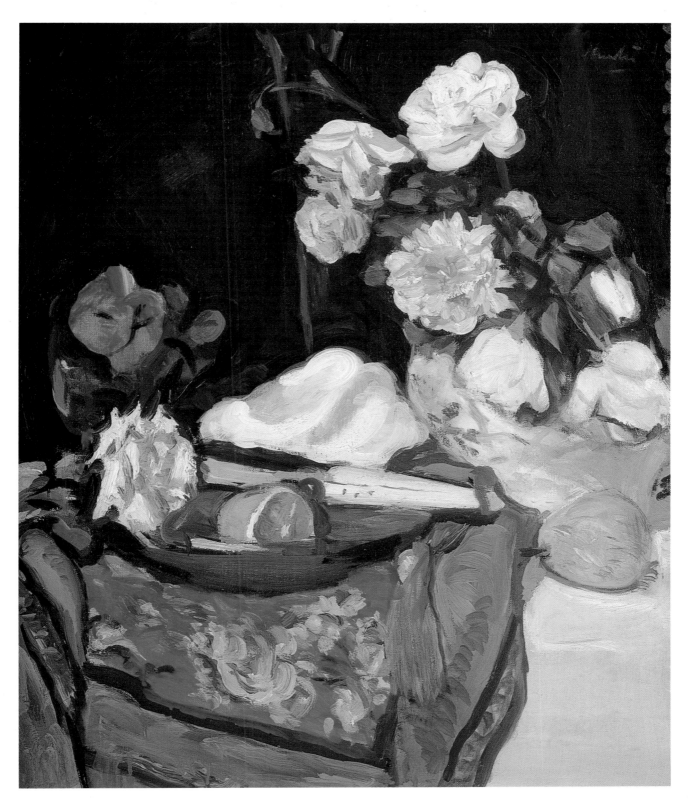

[PLATE 40]
G.L. Hunter *Fruit and Flowers on a Draped Table*, c.1919
Oil on canvas, 61.5 × 51.5
Lord and Lady Irvine of Lairg

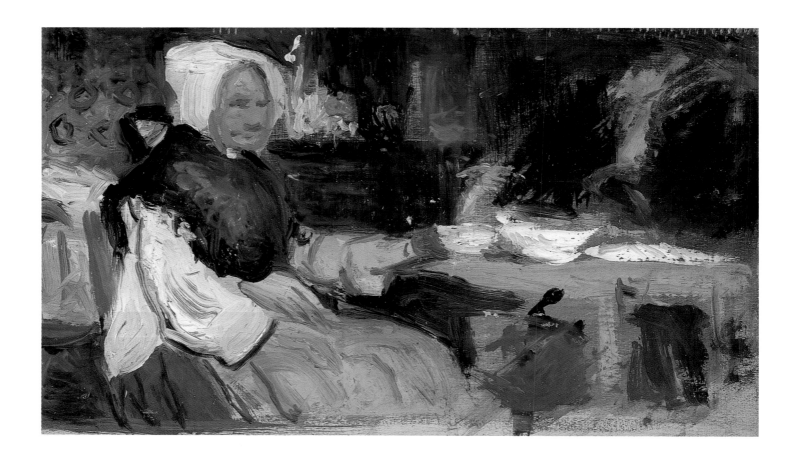

[PLATE 41]
G.L. Hunter *Woman in an Interior*, c.1913
Oil on board, 13 × 22
Private collection

[PLATE 42]
G.L. Hunter *Etaples*, 1914
Oil on board, 26.5 × 35
Private collection

[PLATE 43]
G.L. Hunter *Cottage, near Largo*, c.1919/20
Watercolour and pencil on card, 50.5 × 61
Private collection

[PLATE 44] *opposite*
G.L. Hunter *Sunrise over Fife Harbour*, c.1919/20
Watercolour and pencil on card, 76 × 50.7
Private collection

[PLATE 45]
G.L. Hunter *Juan-les-Pins, c.*1927
Ink and pastel on paper, 35 × 30
Lord and Lady Macfarlane of Bearsden

[PLATE 46]
G.L. Hunter *The Café, Cassis, c.1927*
Ink and pastel on paper, 40 × 45
Lord and Lady Macfarlane of Bearsden

[PLATE 47]

G.L. Hunter *Still Life with Roses, Fruit and Knife, c.1929*

Oil on board, 45.5 × 37.5

Private collection, courtesy Richard Green, London

G.L. Hunter *Still Life with Fruit and Marigolds in a Chinese Vase*, c.1928
Oil on canvas, 59.5 × 49.5
Robert Fleming Holdings Ltd, London

[PLATE 49]
G.L. Hunter *Street in Vence*, c.1928
Oil on canvas, 54 × 65
Private collection, courtesy Ewan Mundy Fine Art, Glasgow

[PLATE 50]
G.L. Hunter *Provençal Landscape*, c.1929
Oil on canvas, 57 × 70
Private collection

[PLATE 51]
G.L. Hunter *Reflections, Balloch, c.*1930
Oil on canvas, 63.5 × 76.2
Scottish National Gallery of Modern Art
(presented by William McInnes 1933)

[PLATE 52]
G.L. Hunter *Houseboats, Balloch, c.1930*
Oil on canvas, 51 × 61.2
Private collection

[PLATE 53]
G.L. Hunter *Still Life*, c.1930
Oil on canvas, 51 × 61.2
Scottish National Gallery of Modern Art
(purchased 1945)

[PLATE 54]
G.L. Hunter *Still Life, Stocks, c.*1930
Oil on canvas, 56 × 45.8
Scottish National Gallery of Modern Art
(bequeathed by Dr R.A. Lillie 1977)

F. C. B. CADELL
1883–1937

'It seems to me more than ever clear that your forte
lies in a gift of colour and light – these seen in a joyous
mood … I imagine I am right in believing you have
something far better and happier to express –
far more of sun and colour …'

JAMES PITTENDRIGH MACGILLIVRAY
Sculptor, 1915

[PLATE 55]
F.C.B. Cadell *Still Life with White Teapot*, 1913
Oil on canvas, 48 × 61
Lord and Lady Macfarlane of Bearsden

[PLATE 56] *opposite*
F.C.B. Cadell *The Model*, c.1912
Oil on canvas, 127.2 × 101.6
Scottish National Gallery of Modern Art
(purchased 1947)

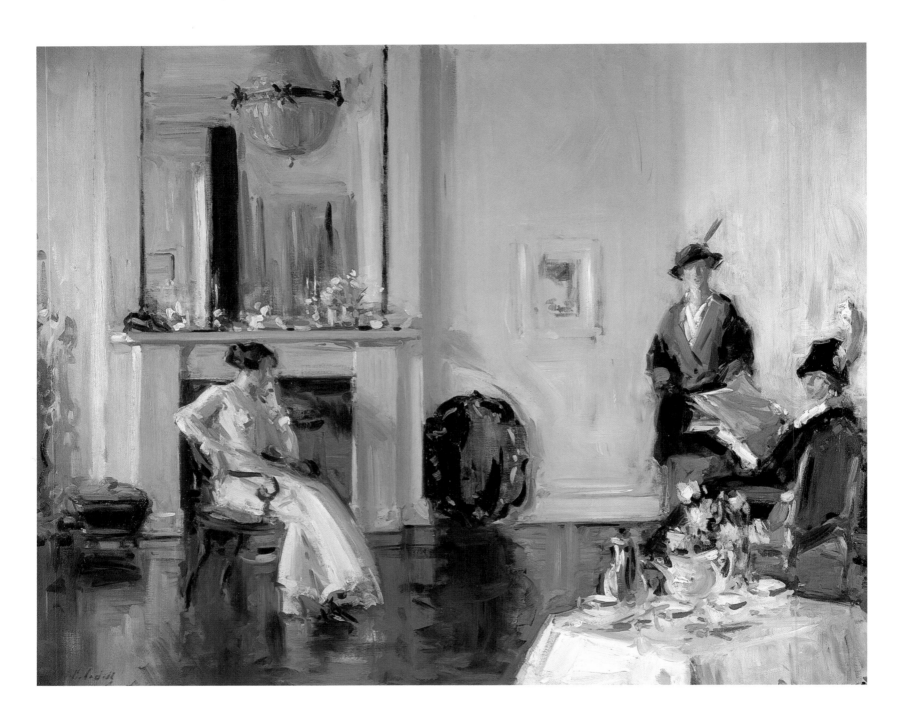

[PLATE 57]
F.C.B. Cadell *Afternoon*, 1913
Oil on canvas, 101.5 × 127
Private collection

[PLATE 58] *opposite*
F.C.B. Cadell *The Black Hat*, 1914
Oil on canvas, 107 × 84.5
City Art Centre, City of Edinburgh Museums and Galleries
(presented by the Scottish Modern Arts Association 1964)

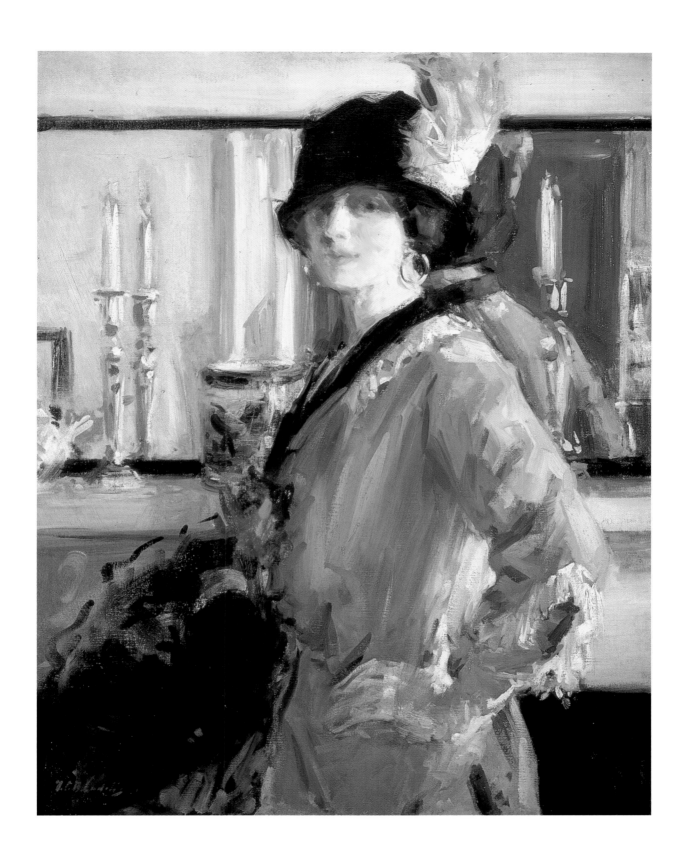

[PLATE 59]
F.C.B. Cadell *The North End, Iona, c.1914*
Oil on canvas, 36 × 44
Private collection

[PLATE 60]
F.C.B. Cadell *Interior of Iona Abbey*, c.1925
Oil on canvas, 70 × 50.8
Private collection

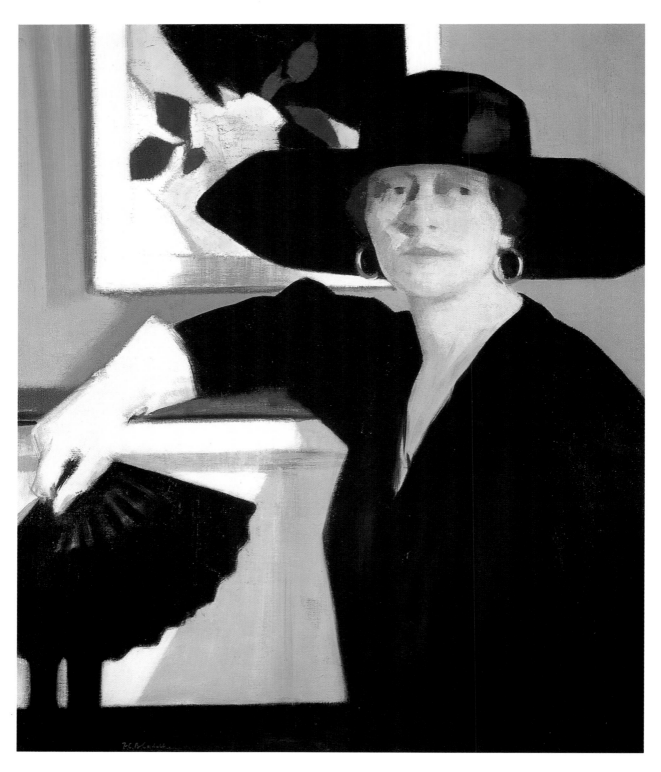

[PLATE 61]
F.C.B. Cadell *Portrait of a Lady in Black, c.1921*
Oil on canvas, 76.3 × 63.5
Scottish National Gallery of Modern Art
(bequeathed by Mr and Mrs G.D. Robinson through
the National Art Collections Fund 1988)

[PLATE 62]
F.C.B. Cadell *The Gold Chair, c.*1921
Oil on canvas, 60.9 × 50.8
Private collection, courtesy Portland Gallery, London

[PLATE 63]
F.C.B. Cadell *The Red Chair*, c.1928
Oil on canvas, 63.5 × 76
Hunterian Art Gallery, University of Glasgow
(bequeathed by Gilbert Innes 1971)

[PLATE 64]
F.C.B. Cadell *The Blue Fan, c.1928*
Oil on canvas, 61 × 50.5
Scottish National Gallery of Modern Art
(bequeathed by Dr James T. Ritchie 1998)

[PLATE 65]
F.C.B. Cadell *Cassis*, **1923/4**
Oil on canvas, 76 × 63.5
Private collection, courtesy Duncan R. Miller Fine Arts, London

[PLATE 66]
F.C.B. Cadell *The Harbour, Cassis*, 1923/4
Oil on plywood, 44.8 × 37.2
Private collection

[PLATE 67]
F.C.B. Cadell *Negro (Pensive)*, *c.*1922
Oil on canvas, 76.6 × 63.9
Private collection

[PLATE 68] *opposite*
F.C.B. Cadell *Lady in Black*, *c.*1925
Oil on canvas, 101.6 × 76.2
Glasgow Museums: Art Gallery and Museum, Kelvingrove (purchased 1926)

[PLATE 69] *opposite*
F.C.B. Cadell *Interior: the Orange Blind*, c.1927
Oil on canvas, 112 × 86.5
Glasgow Museums: Art Gallery and Museum, Kelvingrove
(Hamilton Bequest 1928)

[PLATE 70]
F.C.B. Cadell *Lunga from Iona*, c.1926
Oil on canvas, 51 × 77.2
Gartmore Investment Management

Chronology

This chronology gives all known solo exhibitions of the work of Peploe, Fergusson, Hunter and Cadell together with details of their participation in important group exhibitions held during their lives. Selected exhibitions are given thereafter. *Concurrent events are shown in italic type.*

AAA Allied Artists' Association

RGI Royal Glasgow Institute of Fine Arts

RSA Royal Scottish Academy

RSBA Royal Society of British Artists

RSSW Royal Scottish Society of Painters
 in Watercolour

SSA Society of Scottish Artists

1871
PEPLOE, Samuel John, born on 27 January at 39 Manor Place, Edinburgh, the son of Robert Luff Peploe, Assistant Secretary of the Commercial Bank of Scotland, and his second wife Anne. Educated at the Collegiate School, Edinburgh.

1874
FERGUSSON, John Duncan, born on 9 March at 7 Crown Street, Leith, near Edinburgh, the son of John Fergusson, spirit merchant, and his wife Christina. Educated at The Royal High School, Edinburgh and Blair Lodge School, Linlithgow.

1877
HUNTER, George Leslie, born 7 August in Rothesay, Bute, the son of William Hunter, chemist, and his wife Jeannie. Educated at Rothesay Academy.

1883
CADELL, Francis Campbell Boileau, born on 12 April at 4 Buckingham Terrace, Edinburgh, the son of Francis Cadell, surgeon, and his wife Mary. Educated at The Edinburgh Academy.

1889
In Glasgow Alexander Reid opens gallery, La Société des Beaux-Arts (subsequently referred to here as Alexander Reid's), dealing in Barbizon, Impressionist and Post-Impressionist works; in his first year shows Japanese prints.

c.1891
FERGUSSON considers enrolling at Edinburgh University to study medicine.

1891
PEPLOE gives up working for the Edinburgh legal firm Scott and Glover and begins studies at Edinburgh School of Art.

In Edinburgh SSA founded.

c.1892
HUNTER emigrates with his family to California where his father has invested in an orange farm near Los Angeles.

1892
In Glasgow RGI includes work by Degas, Fantin-Latour, Sickert and Whistler.

In London Alexander Reid holds exhibition 'Pictures by the Great French Impressionists', including work by Degas, Monet, Pissarro and Sisley, (Mr Collier's Rooms, New Bond Street).

1893
James McNeill Whistler becomes godfather to Alexander Reid's son, who is christened McNeill in the artist's honour.

c.1894
FERGUSSON takes studio at 16 Picardy Place, Edinburgh.

1894
PEPLOE goes to Paris and studies at L'Académie Julian, where he is taught by William Bouguereau, and at L'Académie Colarossi, where he is awarded a silver medal. In Paris he shares accommodation with the Aberdeen-born artist Robert Brough.

1895
PEPLOE takes studio in the Albert Building, Shandwick Place, Edinburgh. Awarded Mac-Laine Watters Medal for his work at the RSA life school. Visits Holland.

FERGUSSON possibly visits Paris.

In Glasgow RGI includes work by Monet.

1896
PEPLOE paints at North Berwick. Exhibits in Edinburgh at the RSA and in Glasgow at the RGI (the first time his work shown by either institution).

c.1897
PEPLOE paints on Barra with his brother William Watson Peploe and Robert Cowan Robertson.

1897
PEPLOE exhibits in Edinburgh at the SSA (the first time his work shown there).

FERGUSSON exhibits in Glasgow at the RGI (the first time his work shown there).

In Glasgow RGI includes work by Monet.

1898
FERGUSSON paints in France on the River Loing. Possibly visits Paris and may have attended classes at L'Académie Colarossi. Exhibits in Edinburgh at the RSA and SSA (the first time his work shown by either institution).

1899
FERGUSSON visits Morocco. Exhibits in London at the RSBA and continues to show there until 1907.

CADELL finishes studies in Edinburgh at the RSA schools and goes to Paris at the suggestion of Arthur Melville (a family friend and godfather to Cadell's younger brother), where he attends classes at L'Académie Julian for next three years.

S.J. Peploe, c.1904
National Library of Scotland, Edinburgh

Exhibition Hanging Committee of the California
Society of Artists, c.1902: G.L. Hunter is shown top
left, beside him Blendon Campbell and, in front,
Gottardo Piazzoni, Xavier Martinez and Peter Neilson.
National Library of Scotland, Edinburgh

J.D. Fergusson in France, c.1904
The Fergusson Gallery, Perth

1900

PEPLOE visits Paris. Moves studio to 7 Devon Place, Edinburgh.

FERGUSSON visits Paris.

HUNTER's family returns from California to Scotland. Hunter moves to San Francisco.

1901

FERGUSSON elected to the RSBA. Visits Spain.

HUNTER exhibits at the San Francisco Arts Association.

In Paris Van Gogh retrospective held at Galerie Bernheim-Jeune (71 works).

1902

PEPLOE paints at Comrie, Perthshire.

HUNTER has illustrations published in *The Overland Monthly*, San Francisco (September). Exhibits in the first exhibition of the California Society of Artists.

CADELL exhibits in Edinburgh at the RSA (the first time his work shown there).

In Edinburgh the RSA exhibits work by Whistler (including 'The Little White Girl: Symphony in White no.2', see figure 15).

1903

PEPLOE paints at North Berwick, Comrie and Barra. Has first solo exhibition, in Edinburgh at Aitken Dott & Son (3 November–1 December).

HUNTER has illustrations published in *The Overland Monthly* (February) and *Sunset* (January, February), San Francisco. Possibly returns to Scotland. Has work published in the *Society Pictorial*, Glasgow (monthly from April to December).

In Paris first exhibition of the Salon d'Automne; Gauguin memorial exhibition held at Galerie Ambroise Vollard (40 works).

Death of Gauguin.

1904

PEPLOE and FERGUSSON paint together in Brittany (summer).

HUNTER visits Paris about this time. Has work published in the *Society Pictorial*, Glasgow (January – June, December).

In Edinburgh the RSA exhibits 25 paintings and prints by Whistler.

In Paris the Salon d'Automne includes Cézanne retrospective exhibition (42 works); Matisse has first solo exhibition, at the Galerie Ambroise Vollard (46 works); Van Dongen also exhibits at the Galerie Ambroise Vollard (125 works).

1905

PEPLOE and FERGUSSON paint together in Paris, Dieppe and Paris-Plage.

PEPLOE takes Raeburn's former studio at 32 York Place, Edinburgh.

FERGUSSON has first solo exhibition, in London at the Baillie Gallery (19 May–9 June, introductory catalogue notes by the artist).

HUNTER returns to San Francisco via New York. Has work published in the *Society Pictorial*, Glasgow (July – September) and in *The Overland Monthly*, San Francisco (August, September, October). Exhibits at the San Francisco Artists Society.

In London exhibition of 315 Impressionist paintings held at the Grafton Galleries.

In London and Paris Whistler memorial exhibition held at the International Society of Sculptors Painters and Engravers (approximately 750 works) and at the Ecole des Beaux-Arts (approximately 450 works).

In Paris the Salon d'Automne includes recent work by Matisse, Camoin, Derain, Manguin, Marquet, Puy and Vlaminck, who are referred to as 'Fauves' by the critic Louis Vauxcelles; at the Salon des Indépendants retrospective exhibitions held of Seurat (43 works) and Van Gogh (45 works).

Matisse and Derain paint at Collioure.

1906

FERGUSSON visits Paris-Plage, Le Touquet and Paris. Exhibits in London at the International Society of Painters and Engravers.

HUNTER's work for his first solo exhibition at the Mark Hopkins Institute in San Francisco destroyed by the April earthquake prior to its opening. Returns to Scotland, staying with his mother in Glasgow. Has work published in the *Sunset*, San Francisco (September) and *Society Pictorial*, Glasgow (August).

CADELL moves to Munich with his family.

In Paris the Salon d'Automne includes Gauguin retrospective.

Death of Cézanne.

Derain paints in London.

F.C.B. Cadell, c.1900
National Library of Scotland, Edinburgh

J.D. Fergusson (left) and S.J. Peploe painting
in France, c.1904
The Fergusson Gallery, Perth

S.J. Peploe (standing) and J.D. Fergusson, c.1904
The Fergusson Gallery, Perth

1907

PEPLOE paints at Paris-Plage, and in Paris.

FERGUSSON at Paris-Plage, meets the Americans Anne Estelle Rice and Elizabeth Dryden. Moves to Paris, at first staying at the Hotel de la Haute-Loireat; subsequently moves to 18 Boulevard Edgar Quinet. Teaches at the Academie de la Palette where he meets André Dunoyer de Segonzac. Exhibits in Paris for the first time at the Salon d'Automne (includes *Dieppe, 14th July 1905: Night*, see plate 21) and at the Société Nationale des Beaux-Arts.

In Edinburgh Rodin elected Honorary RSA; Scottish Modern Arts Association founded to form collection of modern pictures as the nucleus of a modern gallery: first acquisitions include works by Walton, Hornel, Paterson and a still life by Peploe, which had been exhibited at that year's RSA exhibition.

In Paris the Salon d'Automne includes work by Braque, Delaunay, Derain, Kandinsky, Matisse and Vlaminck, and a Cézanne memorial retrospective.

1908

PEPLOE exhibits in London alongside Fergusson, Sickert and Lucien Pissarro in *Some Modern Painters* at the Baillie Gallery (October) and has work included in first AAA exhibition, Royal Albert Hall (July – August).

FERGUSSON moves to 83 rue Notre-Dame-des-Champs and meets the American sculptor Jo Davidson (who models Fergusson's bust, see figure 14). Paints at Montgeron. Exhibits in Paris at the Salon d'Automne and Société Nationale des Beaux-Arts. In London has room devoted to his work in the exhibition *Some Modern Painters* at the Baillie Gallery (October) and has work included in first AAA exhibition, Royal Albert Hall (July – August).

CADELL's mother dies in Munich and the family return to Edinburgh. Has first solo exhibition, in Edinburgh at Doig, Wilson and Wheatley (dates unknown).

In London Gauguin, Matisse and Van Gogh exhibit at the International Society.

In Paris première of Diaghilev's production of Mussorgsky's 'Boris Godunov'.

1909

PEPLOE has solo exhibition in Edinburgh at Aitken Dott & Son (March).

FERGUSSON paints at Montgeron. Exhibits in Paris at the Salon d'Automne, of which he is elected a *Sociétaire*. Writes review of the Salon, published in *Art News* (21 October), discussing the influence of Matisse who he describes as 'the painter who annoys the bourgeoisie the most'.

CADELL moves studio to 137 George Street, Edinburgh. Has solo exhibition in Edinburgh at Aitken Dott & Son (November) and exhibits in Glasgow at the RGI (first time his work shown there).

In Paris the Salon d'Automne includes work by Balla, Boccioni, Kandinsky, Léger and Severini.

1910

PEPLOE marries Margaret Mackay and they move from Edinburgh to Paris, taking a studio-apartment at 278 Boulevard Raspail. Peploe paints at Royan with Fergusson and Anne Estelle Rice; birth of the Peploes' first son, William, while there.

FERGUSSON meets John Middleton Murry in Paris. Exhibits in Paris at the Salon d'Automne.

HUNTER moves to London about this time. Has work published in the *Graphic*, London (Christmas issue).

CADELL paints in Venice; visit financed by friend and collector Patrick Ford. Has solo exhibition in Edinburgh at Aitken Dott & Son (16–20 November).

In London Roger Fry's exhibition 'Manet and the Post-Impressionists' held at the Grafton Galleries (8 November 1910–15 January 1911); exhibition of 'Modern French Art', including work by Matisse, Vlaminck, Bonnard, Cézanne and Gauguin, held at the Brighton Art Gallery (London, June); Margaret Morris performs in 'Orpheus and Eurydice' at the Savoy Theatre and dances in 'The Blue Bird' at The Haymarket.

In Paris the Salon d'Automne includes work by Kandinsky, Matisse (including 'Dance' and 'Music' commissioned by Shchukin), Léger and Picabia; Ballets Russes première 'Carnaval', 'Schéhérazade', 'Giselle', 'The Firebird' and 'Les Orientales'; Segonzac publishes his 'Isadora Duncan and Schéhérazade: 24 Drawings for a Russian Ballet'.

1911

PEPLOE paints at Santec, Ile de Bréhat and Cassis. Visits Edinburgh in July. Provides illustrations for *Rhythm*. Exhibits in Edinburgh in group exhibition at Aitken Dott & Son (May – June).

FERGUSSON appointed art-editor of new periodical *Rhythm* (first issue published in summer; editor: John Middleton Murry); Fergusson contributes illustrations regularly and continues as art-editor until November 1912 (last issue published spring 1913). Exhibits in Paris at the Salon d'Automne (includes *La Bête violette* and *Rhythm*, see plates 30, 32) and Salon des Indé-pendants (April – June), which includes a Cubist room.

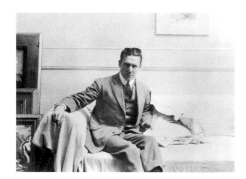

J.D.Fergusson in his Paris studio c.1908
The Fergusson Gallery, Perth

S.J. Peploe,
his wife Margaret
and their son, William, c.1912
National Library of Scotland, Edinburgh

Left to right, standing: F.C.B. Cadell,
Mrs Penny(?), Jean Cadell (the artist's sister),
Captain Penny(?). Seated: Margaret Peploe (the
artist's wife), Denis Peploe (the artist's son), and
S.J. Peploe. Photograph taken by William Peploe
(the artist's son), c.1924
National Library of Scotland, Edinburgh

HUNTER may have met Peploe and Fergusson in Paris. Has work published in the *Graphic*, London (November) and *Harper's Weekly* (July, December).

In Edinburgh Degas elected Honorary RSA.

In London Cézanne and Gauguin exhibition held at the Stafford Gallery (14 works shown); Anne Estelle Rice exhibits at the Baillie Gallery.

1912

PEPLOE and FERGUSSON exhibit in London in *Exhibition of Pictures by J.D. Fergusson, A.E. Rice and Others, The Rhythm Group* held at the Stafford Gallery (October).

PEPLOE family return to Edinburgh in June, taking flat at 13 India Street. Peploe takes studio at 34 Queen Street. Provides illustrations for *Rhythm*. Has solo exhibition of drawings in London at the Stafford Gallery (February).

FERGUSSON has solo exhibitions in London at the Stafford Gallery (February and March). Exhibits in Paris at the Salon d'Automne and in Cologne at the Kunstausstellung des Sonderbundes.

CADELL paints on Iona, the first of regular visits. Together with Patrick William Adam, David Alison, James Cadenhead, John Lavery, Harrington Mann, James Paterson and Alexander Sinclair, founds the exhibiting group The Society of Eight: their first exhibition held in Edinburgh at The New Gallery, 12 Shandwick Place (November).

In London Roger Fry's 'Second Post-Impressionist Exhibition' held at the Grafton Galleries (5 October – 31 December, extended in revised form to 31 January 1913); Futurist painters (including Boccioni, Carrà, Russolo and Severini) show work at the Sackville Gallery; Margaret Morris School moves to Chelsea.

In Edinburgh a selection of works from Fry's 'Second Post-Impressionist Exhibition' is borrowed by the Scottish artist, Stanley Cursiter, and shown at the SSA (16–20 November).

1913

PEPLOE paints on Arran and at Cassis with Fergusson. Has solo exhibition in Edinburgh at The New Gallery (2–24 May).

FERGUSSON meets the dancer Margaret Morris in Paris. Paints at Cassis with Peploe; by September has moved to Cap d'Antibes. His painting *Rhythm* (see plate 32) and three other works included in *Post-Impressionist and Futurist Exhibition*, organised by Frank Rutter and held at the Doré Galleries, London (12 October 1913–16 January 1914).

HUNTER has work published in the *Pall Mall Magazine*, London (March). Has first solo exhibition, in Glasgow at Alexander Reid's (November).

CADELL moves studio to 130 George Street, Edinburgh.

In Glasgow RGI shows paintings by the Futurists, Picasso, Matisse, Vlaminck, Herbin, Gauguin, Sérusier, Cézanne and Van Gogh (autumn); these works transfer to the SSA in Edinburgh (December), where Peploe and Cadell's work is also shown.

1914

PEPLOE and FERGUSSON included in the exhibition *Twentieth-Century Art: A Review of the Modern Movements* held at the Whitechapel Gallery, London (8 May–20 June).

PEPLOE paints at Crawford, Lanarkshire. Birth of the Peploes' second son, Denis. Application to join army refused on health grounds. Has solo exhibition in London at the Baillie Gallery (April).

FERGUSSON in Antibes, designs costumes for *Spring*, a production by the Margaret Morris School. Has solo exhibition in London at the Doré Galleries (February, catalogue introduction by Frank Rutter). Painting at Antibes on outbreak of war; returns to Britain and spends war-period moving between Edinburgh and London.

HUNTER paints at Etaples. Has work published in the *Pall Mall Magazine*, London (January, March).

CADELL's application to join army refused on health grounds.

1915

PEPLOE paints at Kirkcudbright. Has first exhibition in Glasgow, at Alexander Reid's (November).

FERGUSSON takes studio at 14 Redcliffe Road, London. With Margaret Morris, forms Margaret Morris Club, Glebe Place, Chelsea.

HUNTER exhibits in Edinburgh at the RSA (first time his work shown there). Gives address Fairlie Bank, Crow Road, Glasgow.

CADELL joins Royal Scots Guards. Produces drawings on army life which are exhibited in Edinburgh at The Society of Eight and published in 1916 as the book *Jack and Tommy*.

1916

HUNTER works on his uncle's farm at Millburn, near Larkhall, for remainder of war. Has solo exhibition in Glasgow at Alexander Reid's (March) and exhibits at the RGI (first time his work shown there).

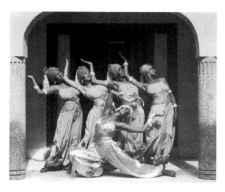

Margaret Morris and her dancers
The Fergusson Gallery, Perth

Sketch by Fergusson, 1922, showing Montparnasse
recollected from his years there in c.1907–13.
His studio is marked at Boulevard Edgar Quinet.
Also shown are the cafés Rotonde, Dôme, Avenue,
The Hole in the Wall, Closerie de Lilas and
Harcourt, frequented by Fergusson's circle
The Fergusson Gallery, Perth

1917

PEPLOE elected Associate of RSA. Paints at
Kirkcudbright.

CADELL has solo exhibitions in Glasgow at
George Davidson Ltd (July and November).

1918

PEPLOE moves studio to 54 Shandwick Place,
Edinburgh.

FERGUSSON paints at Portsmouth Docks. Has
solo exhibition in London at the Connell Gallery
(May, catalogue introduction by John Middleton
Murry).

CADELL made second lieutenant, 11th Batallion
Argyll and Sutherland Highlanders; wounded in
France in July.

1919

PEPLOE has solo exhibition in Glasgow at
Alexander Reid's (November – December).
Paints in Dumfriesshire.

FERGUSSON in London moves to home of
George Davison, Holland Park, and begins to
paint at 15 Callow Street (Margaret Morris's
flat). His work included in group exhibition in
London at the Twenty-One Gallery (September).

CADELL returns from France to Scotland;
resumes visits to Iona.

*In Glasgow Alexander Reid holds exhibition of
153 French paintings (including works by Degas,
Monet, Renoir, Sisley and Vuillard) at the
McLellan Galleries.*

1920

PEPLOE paints on Iona, the first of regular visits
with Cadell.

CADELL moves studio to 6 Ainslie Place,
Edinburgh. Has solo exhibition in Glasgow at
Warneuke's Gallery (December 1920 – January
1921).

*In London Charles Rennie Mackintosh designs
theatre for Margaret Morris.*

1921

PEPLOE has solo exhibition in Glasgow at
Alexander Reid's (December).

HUNTER has solo exhibition in Glasgow at
Alexander Reid's (April).

*In Glasgow Alexander Reid's shows work by
Matisse, Picasso, Vuillard, Dufy and Rouault.*

1922

PEPLOE has solo exhibition in Edinburgh at
Aitken Dott & Son (February – March).

FERGUSSON goes on tour of Scottish Highlands
with author and friend John Ressich (May –
June). Paints in France at Pourville.

HUNTER paints in Paris, Venice, Florence and
Fife. In Paris, visits Epstein and Matisse.

CADELL has solo exhibitions in Glasgow at
Warneuke's Gallery (January) and at Alexander
Reid's (December).

1923

FERGUSSON paints at Antibes. Has solo exhibi-
tion in Edinburgh at Aitken Dott & Son (June);
exhibition transfers to Alexander Reid's, Glas-
gow (September).

HUNTER paints in Paris, Italy and Fife. Exhibits
in Edinburgh at the RSA, giving his studio
address 104 West George Street, Glasgow.

CADELL paints at Cassis.

*Exhibition of Paintings by S.J. Peploe, F.C.B.
Cadell and Leslie Hunter, The Leicester Galler-
ies, London (January).*

1924

PEPLOE paints at Cassis with Cadell. Has solo
exhibitions in Edinburgh at Aitken Dott & Son
(February – March) and in Glasgow at Alexan-
der Reid's (March).

HUNTER visits California and New York. Paints
at Loch Lomond. Has solo exhibition in Edin-
burgh at Aitken Dott & Son (March).

CADELL paints at Cassis with Peploe. Has solo
exhibition at Alexander Reid's, Glasgow (May).

*'Les Peintres de l'Ecosse Moderne, F.C.B. Cadell,
J.D. Fergusson, Leslie Hunter, S.J. Peploe',
Galerie Barbazanges, Paris (2–15 June): French
state acquires work by Peploe from the exhibition.*

*In Glasgow Alexander Reid's shows work by
Matisse, Picasso, Vuillard, Dufy and Rouault.*

1925

PEPLOE paints at New Abbey, near Dumfries.

FERGUSSON from this time based increasingly
in Paris where he stays at the Hôtel des Acadé-
mies, rue de la Grande Chaumière.

HUNTER in Paris with the collector William
McInnes; encourages McInnes to buy still life
by Matisse (La Nappe rose, Glasgow Art Gal-
lery). Has solo exhibition in Glasgow at Alexan-
der Reid's (December).

*'Exhibition of Paintings by S.J. Peploe, Leslie
Hunter, F.C.B. Cadell and J.D. Fergusson', The
Leicester Galleries, London (January; catalogue
introduction by W.R. Sickert).*

S.J. Peploe and his son, Denis, in Cassis, 1924
National Library of Scotland, Edinburgh

From left to right: Jessie M. King, E.A. Taylor,
S.J. Peploe and Mrs William MacDonald, c.1925
National Library of Scotland, Edinburgh

F.C.B. Cadell's studio at 6 Ainslie Place,
Edinburgh

1926

PEPLOE has solo exhibitions in Glasgow at Reid
& Lefevre (April – May) and in London at Reid
& Lefevre (December).

FERGUSSON has solo exhibition in New York at
the Whitney Studio (December).

CADELL has solo exhibition in Glasgow at
Alexander Reid's (January). Holds exhibition at
his studio, 6 Ainslie Place, Edinburgh (25 March
– 3 April).

*Alexander Reid's, Glasgow, amalgamates with
The Lefevre Gallery, London.*

c.1926–7

HUNTER moves to south of France. From spring
1927 his address is the Auberge de la Colombe
d'Or, Saint-Paul.

1927

PEPLOE elected Academician of the RSA. Has
solo exhibition in Edinburgh at Aitken Dott &
Son (December).

CADELL paints at Auchnacraig, Mull. Has solo
exhibition in Glasgow at Reid & Lefevre (April)
and holds exhibition at his studio, 6 Ainslie
Place, Edinburgh (November).

HUNTER in France paints at Antibes and Saint-
Tropez and meets with Fergusson and Segonzac.

1928

PEPLOE paints in Antibes, Cassis (with Hunter)
and in Dumfriesshire. Visits America and in
New York has solo exhibition at C.W. Kraushaar
Galleries (23 January–3 February; his autobio-
graphical notes published in catalogue). Room
devoted to his work at Kirkcaldy Museum and
Art Gallery (July –August, with biographical
note in catalogue by T. Corsan Morton).

FERGUSSON has solo exhibitions in Chicago at
the Chester Johnson Gallery (January), in
London at Reid & Lefevre (February), in Glas-
gow at Reid & Lefevre (March) and in New York
at C.W. Kraushaar Galleries (November).

HUNTER paints at Cassis with Peploe. Has solo
exhibitions in Glasgow at Reid & Lefevre
(February) and in London at Reid & Lefevre
(October – November).

CADELL exchanges his ground-floor flat at 6
Ainslie Place, Edinburgh, for top floor at same
address. Works on commission for poster
designs promoting the Scottish Western Isles.
Has solo exhibition in Glasgow at Reid &
Lefevre (October).

Alexander Reid dies in Glasgow.

1929

PEPLOE has solo exhibitions in Glasgow at Reid
& Lefevre (May) and in London at Reid &
Lefevre (December 1929 – January 1930).

FERGUSSON takes studio in Paris (23 rue
Gazan). Has exhibition of sculpture at The Arts
Club of Chicago (March, loaned by C.W.
Kraushaar Galleries, New York).

HUNTER has solo exhibition in New York at
Ferargil Galleries (24 April – 11 May; catalogue
introduction by Will Irwin). Becomes ill in
France and returns to Glasgow to recover; takes
studio at 65 West Regent Street.

*In Glasgow, T.J. Honeyman joins firm of Reid &
Lefevre.*

1930

PEPLOE has solo exhibition in Edinburgh at
Aitken Dott & Son (March).

HUNTER paints at Loch Lomond. Has solo
exhibition in Glasgow at Reid & Lefevre
(March).

CADELL holds exhibition at his studio,
6 Ainslie Place, Edinburgh (October).

*Stanley Cursiter appointed Director of the
National Gallery of Scotland.*

1931

PEPLOE paints in Kirkcudbright. Has solo
exhibition in Glasgow at Reid & Lefevre (April).

HUNTER paints at Loch Lomond and considers
moving to London. Has solo exhibitions in
Glasgow at Reid & Lefevre (June and Novem-
ber). Dies in Glasgow on 7 December.

CADELL elected Associate of RSA. Has solo
exhibition in Edinburgh at Parson's Gallery
(October).

*'Les Peintres Ecossais, S.J. Peploe, J.D. Fergusson,
Leslie Hunter, F.C.B. Cadell, Telfer Bear, R.O.
Dunlop', Galerie Georges Petit, Paris (1–14
March, catalogue preface by British Prime
Minister, Ramsay MacDonald): French state
acquires one work each by Hunter, Peploe and
Fergusson.*

*In Edinburgh SSA shows twelve works by Edvard
Munch, the first time his work shown in Britain.*

1932

PEPLOE moves studio to corner of Queen Street
and Castle Street, Edinburgh.

FERGUSSON has solo exhibition in London at
Reid & Lefevre (March).

CADELL moves to 30 Regent Terrace, Edin-
burgh. Has solo exhibition in Edinburgh at
Aitken Dott & Son (October) and holds exhibi-
tion in his studio at Regent Terrace (December).

'Paintings by Six Scottish Artists: Peploe, Fergusson, Hunter, Cadell, Bear, Gillies', Barbizon House, London (April – May, catalogue foreword by Gui St Bernard).

'Memorial Exhibition of Paintings and Drawings by Leslie Hunter', Reid & Lefevre, Glasgow (February, catalogue introduction by John Ressich). Reid & Lefevre Glasgow premises close later that year.

1933
PEPLOE paints at Calvine, Perthshire. From October to end of 1934 is a visiting teacher at Edinburgh College of Art.

CADELL has solo exhibition in Glasgow at Pearson & Westergaard (May).

1934
PEPLOE paints at Rothiemurchus. Has solo exhibitions in Edinburgh at Aitken Dott & Son (February), in London at Reid & Lefevre (February – March) and in Glasgow at Pearson & Westergaard (April).

FERGUSSON moves studio in Paris to 6 Place Henri-Delormel on the rue Ernest-Cresson. Has solo exhibition in Glasgow at Pearson & Westergaard (October – November).

CADELL has solo exhibition in Glasgow at Pearson & Westergaard (May).

In Edinburgh SSA shows twenty-five works by Paul Klee.

1935
PEPLOE dies in Edinburgh on 11 October.

CADELL elected to RSSW. Moves to 4 Warriston Crescent, Edinburgh.

1936
FERGUSSON has solo exhibitions in London at Reid & Lefevre (February) and at Barbizon House (November).

CADELL elected RSA.

'Memorial Exhibition of 83 Paintings by S.J. Peploe, RSA' held at Aitken Dott & Son, Edinburgh (April – May, catalogue foreword by James L. Caw).

1937
FERGUSSON exhibits with and becomes President of Le Groupe d'Artistes Anglo-Américain, Paris.

CADELL dies in Edinburgh on 6 December.

'Memorial Exhibition of Paintings by S.J. Peploe RSA', McLellan Galleries, Glasgow (February, catalogue foreword by E.A. Taylor).

T.J. Honeyman publishes 'Introducing Leslie Hunter'.

1938
Peploe's, Cadell's and Hunter's work shown in the Fine Art Section, Palace of Arts, Empire Exhibition, Glasgow (April – October).

1939
FERGUSSON has solo exhibition in London at Reid & Lefevre (February). On outbreak of war leaves Paris for London.

'Three Scottish Painters, S.J. Peploe, Leslie Hunter, F.C.B. Cadell', Reid & Lefevre, London, (January, catalogue foreword by Douglas Percy Bliss)

Peploe, Cadell and Hunter included in 'Exhibition of Scottish Art', Royal Academy of Arts, Burlington House, London (January – March, selected version of 1938 Glasgow Empire Exhibition).

Exhibition of Hunter's work at Pearson & Westergaard, Glasgow (May).

1940
FERGUSSON and Margaret Morris take studio-flat at 4 Clouston Street, Glasgow; founder members of the meeting and exhibiting society, the New Art Club. Fergusson has work included in Twentieth Century British Paintings, at the National Gallery, London.

1941
'S.J. Peploe 1871–1935', National Gallery of Scotland, Edinburgh (March, catalogue introduction by Stanley Cursiter).

1942
FERGUSSON and Margaret Morris founder members in Glasgow of the exhibiting society the New Scottish Group, an offshoot of the New Art Club. Fergusson participates in its exhibitions held in Glasgow annually from 1943 to 1948 and in 1951, 1953 and 1956.

'Leslie Hunter Exhibition', Glasgow Art Gallery (May, catalogue introduction by Stanley Cursiter); transfers to National Gallery of Scotland, Edinburgh (June).

'F.C.B. Cadell, 1883–1937', National Gallery of Scotland, Edinburgh (April, catalogue introduction by Stanley Cursiter), transfers to Glasgow Art Gallery (June).

1943
FERGUSSON publishes Modern Scottish Painting.

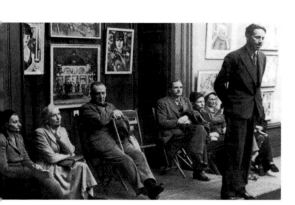

Fergusson (seated, with cane) at the opening of the New Scottish Group exhibition by the Earl of Selkirk, 1951
The Fergusson Gallery, Perth

1947

'Exhibition of Oil Paintings by S.J. Peploe RSA', Ian MacNicol Galleries, Glasgow (*21 April – 7 May*).

'Paintings and Drawings by S.J. Peploe RSA', Aitken Dott & Son, Edinburgh (*18 August – 13 September, catalogue introduction by J.W. Blyth*).

Stanley Cursiter publishes *'Peploe: An intimate memoir of an artist and of his work'.*

1948

FERGUSSON has retrospective exhibition, McLellan Galleries, Glasgow (*5–29 May*); tours to Ayr, Carlisle, Paisley and Belfast.

'Paintings by Four Scottish Colourists, S.J. Peploe, Leslie Hunter, F.C.B. Cadell, J.D. Fergusson', T. & R. Annan & Sons, Glasgow (*November, catalogue foreword by T.J. Honeyman*). First time the term Scottish Colourist is used as an exhibition title.

'Paintings by S.J. Peploe', Reid & Lefevre, London, (*May, catalogue foreword by Stanley Cursiter*).

1949

FERGUSSON has solo exhibition in Glasgow at T. & R. Annan and Sons (*September – October*).

'S.J. Peploe RSA, F.C.B. Cadell RSA and Leslie Hunter', Festival Exhibition, Royal Scottish Academy, Edinburgh (*August – September*).

1950

FERGUSSON made honorary LLD by Glasgow University. Paints in south of France, returning there annually until 1960. Has solo exhibitions in Edinburgh at L'Institut Français d'Ecosse, (*1 February – 10 March*) and in Glasgow at T. & R. Annan & Sons (*November*).

T.J. Honeyman publishes *'Three Scottish Colourists'.*

1951

FERGUSSON has work included in *Fauve Painting in France and Abroad,* Roland, Browse and Delbanco, London (*March – April*).

'Pictures from a Private Collection: Peploe, Fergusson, Hunter, Cadell', Thistle Foundation, Glasgow (*2–27 March, catalogue preface by Stanley Cursiter*).

1952

FERGUSSON has solo exhibition in London at the Hazlitt Gallery (*October – November*).

'Four Scottish Colourists: Peploe, Cadell, Hunter, Fergusson', Saltire Society, Gladstone's Land, Edinburgh (*16 August – 7 September, catalogue foreword by Ian Finlay*).

'Festival Exhibition: Works by Peploe, Hunter, Cadell', Aitken Dott & Son, Edinburgh (*August – September*).

1953

'S.J. Peploe, 1871–1935', Arts Council Scottish Committee touring exhibition (*tour unrecorded, catalogue introduction by Denis Peploe, the artist's son*).

1954

FERGUSSON has touring exhibition organised by the Arts Council Scottish Committee (*tour unrecorded*).

1955

FERGUSSON has solo exhibition in London at Reid & Lefevre (*March*).

'Paintings by Leslie Hunter', The Museum, Rothesay (*10–23 August*), organised by the Arts Council Scottish Committee.

1957

FERGUSSON has solo exhibition in Glasgow at T. & R. Annan & Sons (*7 May–1 June*).

1961

FERGUSSON dies in Glasgow on 30 January.

'J.D. Fergusson: Watercolours and Drawings', Glasgow University Print Room (*25 April – 26 May*).

'J.D. Fergusson Memorial Exhibition' (Arts Council Scottish Committee, catalogue with foreword by André Dunoyer de Segonzac and introduction by Andrew McLaren Young) Royal Scottish Academy (*11 November – 2 December*) and tour to Glasgow, Dundee, Aberdeen, Stirling, Perth and Eastbourne.

'Paintings by J.D. Fergusson', Aitken Dott & Son, Edinburgh (*December*).

1962

'J.D. Fergusson Memorial Exhibition', Pitlochry Festival Theatre (*21 April – 7 July*).

1963

Formation of the J.D. Fergusson Art Foundation by Margaret Morris to administer the artist's estate.

1964

'Retrospective Exhibition of Paintings, Drawings and Sculpture by J.D. Fergusson', The Leicester Galleries, London (*May – June, catalogue introduction by John Russell*).

1965

'J.D. Fergusson', New Charing Cross Gallery, Glasgow (*12 March – 3 April*).

'J.D. Fergusson: Paintings and Drawings from the McColl Collection and other works', Scottish National Gallery of Modern Art (*11–27 June*).

'Watercolours, Gouaches and Drawings by J.D. Fergusson', The Leicester Galleries, London (*December*).

Catalogue cover, *Painting and Sculpture by J.D. Fergusson,* The Connell Gallery, London, 1918

Lord and Lady Macfarlane of Bearsden

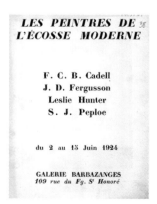

Catalogue cover, *Les Peintres de l'Ecosse Moderne,* Galerie Barbazanges, Paris, 1924

The Fergusson Gallery, Perth

Catalogue cover, *Exhibition of Paintings by S.J. Peploe, Leslie Hunter F.C.B. Cadell and J.D. Fergusson,* The Leicester Galleries, London, 1925

The Fergusson Gallery, Perth

1967

'J.D. Fergusson: The Early Years, Edinburgh 1895 – Paris 1910', Anthony d'Offay Fine Art, London (25 April – 20 May, catalogue introduction by Robert Melville).

'A Man of Influence: Alexander Reid 1854–1928', Glasgow Art Gallery (Scottish Arts Council).

1968

Margaret Morris and J.D. Fergusson Art Foundation present fourteen works by Fergusson to University of Stirling.

1970

'Three Scottish Colourists' (Scottish Arts Council touring exhibition, catalogue introduction by William Hardie), Scottish Arts Council Gallery, Glasgow (9 May – 6 June) and tour to Kilmarnock, Perth, Milngavie, Aberdeen, Dundee, Kirkcaldy and Edinburgh.

'Nudes and Bathers by J.D. Fergusson', The Leicester Galleries, London (5–30 May).

1972

'Paintings from the University Collection: J.D. Fergusson', MacRobert Art Centre, University of Stirling (summer).

'J.D. Fergusson', The Compass Gallery, Glasgow (17 June – 13 July).

1974

'J.D. Fergusson 1874–1961', The Fine Art Society, London (10 September – 4 October) and tour to Glasgow and Edinburgh.

1977

'Three Scottish Colourists', The Fine Art Society, Edinburgh and London (February – April, catalogue introduction by Richard Calvocoressi).

1979–80

'Post-Impressionism', Royal Academy of Arts, London (17 November 1979 – 16 March 1980, includes work by Fergusson and Peploe).

1980

'The Scottish Colourists', Guildford House Gallery (March – June, catalogue introduction by Richard Calvocoressi).

Margaret Morris dies on 29 February.

1982

'J.D. Fergusson: 1905–15', Crawford Centre for the Arts, St Andrews (April, catalogue introduction by Diana Sykes).

1983

'F.C.B. Cadell Centenary', The Fine Art Society, Glasgow, Edinburgh and London (October – December).

1985

'S.J. Peploe 1871–1935', Scottish National Gallery of Modern Art, Edinburgh (26 June–8 September, catalogue introduction by Guy Peploe).

'Colour, Rhythm and Dance, Paintings and Drawings by J.D. Fergusson and his Circle in Paris', (Scottish Arts Council, catalogue essays by Elizabeth Cumming, Sheila McGregor and John Drummond) Glasgow Art Gallery and Museum (6 September – 13 October) and tour to Dundee, Edinburgh, Aberdeen and Avignon.

1988

'F.C.B Cadell', Portland Gallery, London and Bourne Fine Art, Edinburgh (November – December).

'Two Scottish Colourists: Peploe and Cadell', Reid & Lefevre, London (24 November – 16 December, catalogue introduction by Ian Dunlop).

1989

'Scottish Art Since 1900' (catalogue introduction by Keith Hartley), Scottish National Gallery of Modern Art, Edinburgh (17 June – 24 September); Barbican Art Gallery, London (8 February – 16 April).

'The Scottish Colourists', Ewan Mundy Fine Art, Glasgow (November).

1990

'George Leslie Hunter 1877–1931', Duncan R. Miller Fine Arts, London (June, catalogue introduction by Jill MacKenzie).

'John Duncan Fergusson 1874–1961', Duncan R. Miller Fine Arts, London (July, catalogue introduction by Sheila McGregor).

'S.J. Peploe', The Scottish Gallery (Aitken Dott & Son), Edinburgh (7 September – 2 October, catalogue introduction by Guy Peploe).

1991

Establishment of Fergusson Gallery, Perth, with gift of holdings from the J.D. Fergusson Art Foundation.

1993

'Samuel John Peploe 1871–1935', Duncan R. Miller Fine Arts, London (November, catalogue introduction by Guy Peploe).

1996

'The Scottish Colourists', Duncan R. Miller Fine Arts, London (November).

1997

'Modern Art in Britain', Barbican Art Gallery, London (20 February – 26 May, includes work by Fergusson and Peploe).

1998

'Full of the Warm South; The Scottish Colourists and France', City Art Centre, Edinburgh (1 August – 3 October).

1999

'Le fauvisme ou "l'épreuve du feu"', Musée d'Art moderne de la Ville de Paris, (29 October 1999 – 27 February 2000, includes work by Peploe and Fergusson).

Catalogue cover,
J.D. Fergusson, The Whitney Studio
New York, 1926
Lord and Lady Macfarlane of Bearsden

Catalogue cover,
S.J.Peploe, C.W. Kraushaar Art Galleries,
New York, 1928
Lord and Lady Macfarlane of Bearsden

Catalogue cover, *Les Peintres Ecossais, S.J. Peploe, J.D. Fergusson, Leslie Hunter, F.C.B. Cadell …*, Galeries Georges Petit, Paris, 1931
Lord and Lady Macfarlane of Bearsden

Select Bibliography

The following bibliography excludes references to exhibition catalogues. Details of exhibitions are included in the chronology.

GENERAL

R. Billcliffe, *The Glasgow Boys*, London 1985

R. Billcliffe, *The Scottish Colourists*, London 1989, reprinted 1996

W.G. Blaikie Murdoch, *Memories of Swinburne and other essays*, Edinburgh 1910, pp.36–43

J.L. Caw, *Scottish Painting – Past and Present 1620–1908*, London 1908, pp.451–2

D. Cooper, 'A Franco-Scottish link with the Past', *Alex Reid & Lefevre 1926–1976*, London 1976

K. Coutts-Smith, 'Scottish Painting in London', *Scottish Art Review*, vol.XI, no.3, 1968, pp.10–13, 28

A.J. Eddy, *Cubists and Post Impressionism*, London 1915, p.47

W. Egerton Powell, 'Recent Art Exhibitions, Dunfermline Fine Art Exhibition', *Art Work*, vol.II, no.7, 1926, p.141

I. Finlay, *Art in Scotland*, London 1948

H. Furst, 'Round the Galleries', *Apollo*, vol.XXIX, February 1939, pp.98–9

W. Hardie, *Scottish Painting 1837–1939*, London 1976, revised edition *Scottish Painting 1837 to the Present*, London 1990

T.J. Honeyman, 'Art in Scotland', *Studio*, vol.CXXVI, 1943, p.73

T.J. Honeyman, *Three Scottish Colourists* (incorporating I. Harrison, 'As I Remember Them'), London 1950

T.J. Honeyman, *Art and Audacity*, London 1971

F.A. Lea, *Life of John Middleton Murry*, London 1959

M. Macfall, 'A History of Painting', vol.VIII *The Modern Genius*, London 1911

D. Macmillan, *Scottish Art 1460–1990*, Edinburgh 1990, revised edition 2000

C. Marriott, *Modern Movements in Painting*, London 1920, pp.155–6

C.R. Marx, 'The Paris Galleries', *Studio*, vol.CI, 1931, p.375

C. Nathanson, *The Expressive Fauvism of Anne Estelle Rice*, New York 1997

A. Salmon, 'Letter from Paris', *Apollo*, vol.XIII, April 1931, pp.240–3

Three Scottish Colourists (foreword by T.J. Honeyman; introduction by W. Hardie), Edinburgh 1970

J. Tonge, *The Arts of Scotland*, London 1938

CADELL

F.C.B. Cadell, *Jack and Tommy*, London 1916

Connoisseur, vol.XXXVI, May – August 1913, pp.271–2

Glasgow Herald, 1 January 1921, p.4; 5 December 1922, p.12; 7 December 1937, p.11

T. Hewlett, *Cadell, The Life and Works of a Scottish Colourist 1883–1937*, London and Edinburgh 1988

Royal Scottish Academy 110th Annual Report, Edinburgh 1937, pp.12–13

Studio, vol.LVII, 1913, p.326; vol.LXI, 1915, pp.58–9; vol.LXVII, 1916, p.59; 1917, pp.96–7; vol.LXXII, 1917, pp.116–17; vol.LXXXVI, 1923, p.287

FERGUSSON

The Artist, vol.XIII, 1937, pp.86–9

Colour, Rhythm and Dance: Paintings and Drawings by J.D. Fergusson and his Circle in Paris (ed. E. Cumming), Edinburgh 1985

J.D. Fergusson, *Modern Scottish Painting*, Glasgow 1943

J.D. Fergusson, 'Art and Atavism: the Dryad', *Scottish Art and Letters*, no.1, 1944, pp.47–9

J.D. Fergusson, foreword, *The New Scottish Group*, Glasgow 1947

J.D. Fergusson, 'Chapter from an autobiography', *Saltire Review*, vol.VI, no.21, 1960, pp.27–32

M. Hopkinson, 'The Prints of J.D. Fergusson', *Print Quarterly*, vol.XVI, 1999, pp.163–7

S. McGregor, *J.D. Fergusson: The Early Years 1874–1918*, unpublished M.Litt thesis, Courtauld Institute of Art, London 1981

M. Morris, *My Life in Movement*, London 1969

M. Morris, *The Art of J.D. Fergusson: A Biased Biography*, Glasgow and London 1974

M. Morris, *Café Drawings in Edwardian Paris from the Sketch-books of J.D. Fergusson*, Glasgow 1974

Scottish Art Review, vol.VII, no.3, 1960, pp.20–3

Scottish Field, vol.CIII, March 1955, pp.44–6

Studio, vol.XL, 1907, pp.202–10; vol.LIV, 1912, pp.203–7

HUNTER

Bailie, 'Review of exhibition of Alex. Reid', Glasgow, vol.88, March 1916, p.7

I. Finlay, *The Making of a Reporter*, New York 1942, pp.150–2

H. Furst, 'Oils and Drawings in Colour by Leslie Hunter', *Apollo*, vol.VIII, 1928, p.380

Glasgow Herald, George Leslie Hunter obituary, 7 December 1931

T.J. Honeyman, *Introducing Leslie Hunter*, London 1937

T.J. Honeyman, 'Leslie Hunter', *Colville's Magazine*, vol.XX, May 1939, pp.110–13

T.J. Honeyman, 'The McInnes Collection', *Scottish Art Review*, vol.I, no.1, 1946, pp.21–2

M. Hopkinson, 'California, Scotland and Paris: The Prints of Leslie Hunter', *Print Quarterly*, vol.XVI, 1999, pp.247–65

PEPLOE

J.L. Caw, 'Studio Talk – Edinburgh', *Studio*, vol.XXX, 1904, p.161

S. Cursiter, *Peploe: An intimate memoir of an artist and his work*, London 1947

J.D. Fergusson, 'Memories of Peploe', *Scottish Art Review* vol.VIII, no.3, 1962, pp.8–12, 31–2

D. Foggie, 'Peploe's Art', *The Scotsman*, 14 October 1935

D. Foggie, 'S.J. Peploe RSA', *Outlook*, vol.I, no.10, January 1937, pp.46–50

H. Furst, 'Art News and Notes; New Paintings by S.J. Peploe', *Apollo*, vol.XI, January 1930, p.69

Glasgow Herald, Samuel John Peploe obituary, 14 October 1935

T.J. Honeyman, 'S.J. Peploe RSA', *Artist*, December 1935, pp.121–4

T.J. Honeyman, 'S.J. Peploe RSA', *Colville's Magazine*, July 1939, pp.153–5

T.J. Honeyman, 'A Great Scottish Colourist', *Scottish Art Review*, vol.II, no.1, 1948, pp.28–9

G. Peploe, *Samuel John Peploe*, Edinburgh 2000

F.P. Porter, 'An Appreciation: S.J. Peploe', *The Scotsman*, 15 October 1935

F.P. Porter, 'The Art of S.J. Peploe', *New Alliance*, vol.VI, no.6, December 1945 – January 1946

Royal Scottish Academy 108th Annual Report, 'Samuel John Peploe', 1935, pp.13–15

G. St Bernard, 'Works of S.J. Peploe', *Creative Art*, vol.XIII, February 1931, pp.103–8

The Scotsman, Samuel John Peploe obituary, 14 October 1935

Studio, vol.LV, 1912, pp.227–8; vol.LVI, 1912, pp.223–4; vol.LXI, 1914, p.65; vol.LXI, 1914, p.232; vol.LXX, 1917, p.43; vol.LXXVII, 1920, pp.120–4; vol.XCIII, 1927, pp.119–20

A.R. Sturrock, 'Kirkcaldy's riches', *Scottish Art Review*, vol.VI, no.2, 1957, pp.7–10

E.A. Taylor 'S.J. Peploe RSA', *Studio*, vol.LXXXVII, 1924, pp.63–4

Notes

The Scottish Colourists: an Introduction *pages 11–39*

1. R. Fry, 'The Post-Impressionists', introduction to exhibition catalogue *Manet and the Post-Impressionists*, Grafton Galleries, 1910, p.12.

2. Fergusson quoted in Morris, 1974, p.45.

3. The *Connoisseur*, vol.XXXVI, May – August 1913, pp.271–2.

4. Peploe quoted in Cursiter, 1947, p.74.

5. Cursiter, 1947, p.8.

6. Presented to the National Gallery of Scotland by William McEwan 1885.

7. Porter, 1945–6, p.7.

8. Fergusson, 1943, p.49.

9. Morris, 1974, p.14.

10. Fergusson quoted in Morris, 1974, pp.50–1.

11. Ibid., p.50.

12. Fergusson, 1943, p.41.

13. Fergusson quoted in Morris, 1974, p.53.

14. Ibid., p.55.

15. These were *Lady with a Red Rose*, 'Humoreske', *The Green Feather*, and *Dieppe, 14 July 1905: Night* (cat.nos.593–6 respectively).

16. J. Davidson, *Between Sittings, an informal autobiography of Jo Davidson*, New York, 1951, p.38.

17. Ibid., p.46.

18. Fergusson quoted in Morris, 1974, p.45.

19. Cursiter, 1947, p.17.

20. Ibid.

21. Morris, 1974, p.55.

22. Fergusson quoted in Morris, 1974, p.45.

23. Honeyman, 1937, p.45.

24. Ibid., pp.58–9.

25. E.A. Taylor quoted in Honeyman, 1937, pp.72–3.

26. Manuscript draft for 'Notable Scottish Painters V, S.J. Peploe RSA', Honeyman papers, National Library of Scotland, acc.9787.47. Completed article published in *The Artist*, December 1935, pp.121–4.

27. 'Review of exhibition of Alex. Reid, Glasgow', *Bailie*, March 1916, vol.88, p.7.

28. Honeyman, 1937, pp.56, 97.

29. Provenance: *The Alexander Reid Collection of Scottish Colourists*, Morrison, McChlery & Co., Glasgow, 19.5.1967, lot 192; Phillips, Edinburgh, 6.12.1991, lot 45.

30. Undated letter from Cadell, 8 Rue Campagne, Paris, to his father, Cadell papers, National Library of Scotland, acc.11224.1.

31. Works by Cadell entitled *A Modern Cythera* and *Atlanta and Hippomenes* were sold by Christie's Scotland on 3.7.1980 (lot 31) and 30.11.1982 (lot 436) respectively.

32. Hewlett, 1988, p.27 notes that works sold comprised still lifes and a painting of a woman dressed in white posed on a sofa.

33. S. Cursiter, introduction to exhibition catalogue, *F.C.B. Cadell 1883–1937*, National Gallery of Scotland, Edinburgh 1942.

34. Cadell quoted in Honeyman, 1950, p.83.

35. *The Connoisseur*, vol.XXXVI, May-August 1913, p.271, described Cadell as 'a young impressionist who has made astounding progress'.

36. Ibid., p.272.

37. Letter from Pittendrigh MacGillivray to Cadell, 23.2.1915, Cadell papers, National Library of Scotland, acc.11224.1.

38. Cursiter, 1947, pp.29–30.

39. *The Scotsman*, 13.12.1913, p.10.

40. Letter from Peploe to Cadell, 20.6.1918, Cadell papers, National Library of Scotland, acc.11224.1.

41. Letter from Peploe to Cadell, 2.8.1918, Cadell papers, National Library of Scotland, acc.11224.1.

42. Ibid.

43. Morris, 1974, p.104.

44. *The Scotsman*, 24.1.1920.

45. W.R. Sickert, introduction to exhibition catalogue, *Exhibition of Paintings by S.J. Peploe, Leslie Hunter, F.C.B. Cadell and J.D. Fergusson*, The Leicester Galleries, London 1925.

46. Honeyman, 1950, p.45.

47. Morris, 1974, p.88.

48. Ibid., pp.199–201.

49. Fergusson quoted in Morris, 1974, p.199.

50. Private collection; formerly in the possession of T.R. Honeyman.

51. Honeyman, 1937, p.120 notes Hunter owned a painting by Monticelli, which was sold in Paris around 1927.

52. Letter from Hunter to A.J. McNeill Reid, quoted in Honeyman, 1937, pp.121–2.

53. Letter from Hunter to Andrew Justice, quoted in Honeyman, 1937, p.85.

54. Honeyman, 1937, p.139.

55. Letter from Fergusson to John Ressich, 3.12.1931, Fergusson Gallery Archive, acc.1551.

56. Quoted in Cursiter, 1947, p.74.

57. Peploe quoted in Cursiter, 1947, p.73.

58. J.D. Fergusson, *Modern Scottish Painting*, Glasgow, 1943; Fergusson also wrote various convention pamphlets on the subject, copies of which are in the Fergusson Gallery Archive.

59. Fergusson notes written for convention pamphlet for William Power, 1942, Fergusson Gallery Archive, acc.3327.1.

60. Fergusson quoted in Morris, 1974, p.103.

61. *Chicago Tribune*, 1.3.1931.

'Les Peintres de l'Ecosse Moderne': the Colourists and France *pages 41–55*

1. Herbert Read, *Contemporary British Art*, Harmondsworth, 1951, revised edition 1964, pp.25–6.

2. André Dunoyer de Segonzac, foreword to the *Catalogue of the J.D. Fergusson Memorial Exhibition*, Edinburgh, 1961, p.3.

3. Roberta K. Tarbell, *Marguerite Zorach: The Early Years 1908–1920*, Washington, 1973; Marilyn Friedman Hoffman and Roberta K. Tarbell, *Marguerite and William Zorach, the Cubist Years 1915–1918*, Manchester, New Hampshire, 1987. For William Zorach see also *Art is my Life: The Autobiography of William Zorach*, Cleveland and New York, 1967; Donelson F. Hoopes, *William Zorach: Paintings, Watercolors and Drawings, 1911–1922*, New York, 1969. Hazel Clark in her article 'The textile art of Marguerite Zorach', *Woman's Art Journal*, Knoxville, vol.16, no.1, Spring/Summer 1995, pp.18–25, concentrates largely on Marguerite Zorach's career as a tapestry artist in the 1920s.

4. For example, Carol Nathanson, 'Anne Estelle Rice: Theodore Dreiser's "Ellen Adams Wrynn"', *Woman's Art Journal*, Knoxville, vol.13, no.2, Fall 1992/Winter 1993, pp.3–11; *The Expressive Fauvism of Anne Estelle Rice*, New York, 1997. Dr Nathanson is currently completing a monograph on Rice.

5. Mark Antliff, *Inventing Bergson: Cultural Politics and the Parisian Avant-garde*, Princeton, 1993.

6. Fergusson, 1962, pp.9–10.

7. Ibid.

8. Quoted in Billcliffe, 1989, p.19.

9. Hopkinson, 1999, pp.163–8. Fergusson's interest in graphic work culminated in his art editorship of the arts journal *Rhythm* in 1911–12.

10. Nathanson, 1997, p.7: see also Elizabeth Dryden's own account in *Paris in Herrick Days*, New York, 1915. Fergusson's *The Red Shawl*, 1908 (University of Stirling) is a portrait of Dryden. Fergusson himself was to act as an art editor of the Wanamaker trade journal, which he supplied with illustrations.

11. I am much indebted to Carol Nathanson for sharing her research on Rice and Dreiser and for so willingly assisting in locating illustrations for this essay. Dreiser's autobiography *A Traveler at Forty* (New York, 1913) also records his time in Paris in the pre-war years.

12. Theodore Dreiser, 'Ellen Adams Wrynn', *A Gallery of Women*, English edition, London, 1930, p.107: Dreiser had met Rice, and through her Fergusson, in Paris in January 1912.

13. Ibid., pp.106–7. Dreiser also (p.102) defines McKail as a Dundonian who 'speaks with a burr … has a broad, trudging figure and a will of iron'.

14. J. Holbrook Jackson, 'John Duncan Fergusson and His Pictures' in *Today*, vol.III, London, 1918, p.108.

15. Fergusson moved to a studio at 83 rue Notre-Dame-des-Champs in late 1908 or early 1909.

16. Fergusson also showed at the Société Nationale des Beaux-Arts in 1907 and 1908 and the Salon des Indépendants in 1911 and 1912.

17. Fergusson, 1962, p.12.

18. Anne Estelle Rice, 'Les Ballets Russes', *Rhythm*, 11, London, August 1912, p.107: quoted in Nathanson, 1997, p.7.

19. Dreiser, p.103 (see note 12).

20. Peploe used a similar approach in his oil study of his wife Margaret of *c*.1911 (cat.53, *S.J. Peploe*, Scottish National Gallery of Modern Art, 1985)

21. See Alvin Martin and Judi Freeman, 'The Distant Cousins in Normandy: Braque, Dufy and Friesz', *The Fauve Landscape* (ed. Judi Freeman), New York, 1990, p.235.

22. The Café d'Harcourt in the Boulevard St Michel was frequented by working-class girls and enlivened by a Hungarian band. See Morris, 1974, p.63, also John Middleton Murry, *Between Two Worlds: An Autobiography*, London, 1935, p.131.

23. Holbrook Jackson remembered on his visit to Fergusson's studio in 1909 seeing on a white table a 'dark bowl full to the brim, not of flowers, but of those peculiarly shrill pink matchstalks which were at that time a common object of the Parisian café table'. Fergusson also kept a box, rumoured to contain contraceptives, of the same colour in his studio: it appears in a number of still lifes of 1910–11 including *La Bête violette*.

24. J.D. Fergusson, 'The Autumn Salon', in *Art News*, 21, London, October 1909.

25. 'Mes toiles … prennent toutes leurs sources dans la nature': from the catalogue to Chabaud's one-man show at Bernheim-Jeune & Co., Paris, 1912.

26. Letter of 13 December 1939 from E.A. Taylor to the director of Glasgow Art Gallery, T.J. Honeyman (Honeyman Papers, University of Glasgow: quoted by William Hardie in his introduction to *Three Scottish Colourists*, Edinburgh, 1970, p.10 and in Hardie, 1976, p.93.

27. Rice here uses a stylised floral backcloth to her own reflection as well as a 'real' still life in the foreground to express her feminine identity: she again used a flowered background for the portrait of her friend, the writer Katherine Mansfield whom she met through Murry in Paris in 1912 and painted in 1918 (Te Papa Tongarewa Museum, Wellington, New Zealand).

28. Tarbell, 1973, p.17 (see note 3). Fergusson was unusual in teaching a mixed life class. Zorach, 1967, p.22 (see note 3), recalled how he 'wound up studying in a school called La Palette run by a Scotch artist, J.D. Ferguson [sic]. Here, Jacques-Emile Blanche criticised in English. He came in twice a week, an impressive, beautifully mannered Frenchman, a very successful portrait painter – with almost nothing to say – a few words, "too short, too tall, a bit more here, a bit less there, not bad, keep right on"'. Zorach and Thompson not only visited Gertrude Stein, previously known to Thompson's aunt from San Francisco days, but went to the Salon des Indépendants ('a big sprawling affair in an enormous tent') on varnishing day where they saw, 'Matisse putting the final touches to his big painting, *The Red Interior* … it was a fantastic show, ranging from the inept and childish, through the most dull and conservative, to the latest in wild experimentation'.

29. Zorach, 1967, p.33 (see note 3).

30. Aileen Smith, 'The Construction of Cultural Identity in the Visual Arts in Scotland 1918–1945', unpublished PhD thesis, University of Aberdeen, 1998, discusses the conservatism of taste and cultural attitude in Edinburgh in the period 1910 to 1939.

31. Fort had launched his journal *Vers et prose* in the Closerie des Lilas in March 1905.

32. Marcel Giry and Réné Jullian, *Othon Friesz (1879–1949)*, catalogue of an exhibition organised by the Friends of the Musée de Lyon, 1953: 'Friesz construit le paysage par volumes et l'organise suivant un rhythme'.

33. Lea, 1959, p.20.

34. Lea, 1959, p.135.

35. Murry had hoped to have the journal distributed internationally from London, Edinburgh and Glasgow to New York and Munich.

36. For a detailed discussion of the origins and development of *Rhythm*, see Sheila McGregor, 'J.D. Fergusson and the Periodical *Rhythm*' in *Colour, Rhythm and Dance*, 1985, pp.13–17, also Antliff, pp.71–83 .

37. Lea, 1959, p.156.

38. The character of Raoul Duquette in Katherine Mansfield's *Je ne parle pas francais* (1919) was based on Carco, with whom she had had an affair in 1915.

39. Judi Freeman, 'Surveying the Terrain: the Fauves and the landscape', *The Fauve Landscape*, p.32 (see note 21).

40. Antliff, p.84 (see note 5).

41. Nathanson, 1992, p.5 and 1997, p.11 (see note 4).

42. *Colour, Rhythm and Dance*, 1985, p.9.

43. Huntly Carter, *The New Age*, 10 August 1911, p.345: quoted in Antliff, p.85 (see note 5).

44. J.D. Fergusson, 'Chapter from an Autobiography', *Saltire Review*, vol.VI, no.21, Edinburgh, 1960, pp.27–32: quoted in Billcliffe, 1989, p.33. Fergusson's account of domesticity, details how he used a travelling rubber bath in the hall of his studio apartment. He recalled, 'Often I had to open the front door, slightly, if I was in the nude, to explain to callers. When Epstein wanted to do something about the Wilde monument, for example'. That Epstein should call on Fergusson for help indicates an earlier friendship between the two men. Evelyn Silber, in *Jacob Epstein: Sculpture and Drawings*, Leeds and London, 1987, p.127, suggests a date of late September 1912 for a letter from Epstein to Francis Dodd, in which he describes how the sexual organs of the Wilde monument had been 'swaddled in plaster ... the Prefect of the Seine and the Keeper of the École des Beaux-Arts had been called in and decided that I must either castrate or figleaf the monument! ... I am going of course to get Léon Bakst and any other influential people I know here to stop all this miserable business ...'

45. Fergusson's own few attempts at sculpture included a stone head of 1915, *Ténèbres* (Fergusson Gallery, Perth) which is more explicitly orientalist in its facial features.

46. Morris, 1974, p.88.

47. Nathanson, 1992, p.6 (see note 4): the painting is lost but Carter's illustration is reproduced in Nathanson, 1997, p.21.

48. Huntly Carter, *The New Spirit in Drama and Art*, London, 1912, pp.217–8: quoted in Nathanson, 1997, p.22.

49. Billcliffe, 1989, p.30.

50. Frances Fowle, 'Alexander Reid in context: collecting and dealing in Scotland in the late 19th and early 20th centuries', unpublished PhD thesis, University of Edinburgh, 1994, discusses Reid's career in detail.

51. Billcliffe, 1989, p.49.

52. Recalled by Will Irwin in the introduction to the catalogue to the exhibition of work by Leslie Hunter held at the Ferargil Galleries, New York in 1929: quoted in Billcliffe, 1989, p.49.

53. 'Messrs Whytock and Reid's Furniture', *The Studio*, vol.94, no.412, London, 1927, p.18.

Appendix: Memories of Peploe

J.D. FERGUSSON

My memories of S.J. Peploe are the memories of our friendship which was wonderful and interesting all the time. Nothing about it was spectacular. It was merely a happy unbroken friendship between two painters who both believed that painting was not just a craft or profession but a sustained attempt at finding a means of expressing reactions to life in the form demanded by each new experience. This is quite different from arriving at a way of doing a thing and continuing to do it in a tradesmanlike manner. By life we meant everything that happened to us; and, as we were curious about life, we painted all sorts of things – men, women, children, landscape, sea-pieces, flowers, still-life – anything. All I can do about such a friendship is to give a few glimpses of it in the hope that they will reveal something of my old friend.

Peploe was a great admirer of Henry James and had in himself something of the 'restless analyst'. *What Maisie Knew* was one of his favourite books. I remember him saying that Henry James had created one of his characters, a waiter, from a passing glimpse. Perhaps he was interested in this idea because he himself did not create from passing glimpses. When he made a portrait he had to ponder long over what he was doing. But painting someone you know really well can also be very difficult. I tried it for years with my father and mother and never kept any of my attempts. There was too much about them that was beyond anything I could put on canvas. My father had brought me up on Robert Burns; my mother had created my first impression of painting and design by telling me the story of the

willow pattern plate I had my porridge in when I was a very small boy. I can feel her sitting beside me, a very young woman, telling me about the people crossing the bridge and about the birds. Often today, two pigeons fly past my window making the pattern I remember from my porridge plate. Every time I reach to my willow pattern butter dish I think of my mother. This is not a glimpse of her; it is something of her that has become part of my life.

Before we met, Peploe and I had both been to Paris – he with Robert Brough and I alone. We were both very much impressed with the Impressionists whose work we saw in the Salle Caillebotte in the Luxembourg and in Durand-Ruel's Gallery. Manet and Monet were the painters who fixed our direction, in Peploe's case Manet especially. He had read George Moore's *Modern Painting* and Zola's *L'Œuvre*; I had read nothing about painting. At that time hardly anyone in Britain had heard of Cézanne. I was daft about painting and had given up the idea of medicine to devote myself entirely to it. When we met, S.J. and I immediately became friends and I found great stimulation in telling him my ideas about art. We discussed everything. Those were the days of George Moore, Henry James, Meredith Wilde, Whistler, Arthur Symons and Walter Pater. I remember sitting on the rocks at the extreme north of Islay and reading Walter Pater's essay on Mona Lisa and discussing it with Peploe. At that time I was very interested in French poetry and claimed that without knowing French thoroughly I could get a great deal out of Gautier's *Emaux et Camées*, merely as a sound composition of words. S.J. did not

admit this, and we discussed it often. We did not know about Druidic incantations which do not depend for their force on what people call making sense.

Another thing we tried to understand was time, starting from the feeling that while you are doing a thing for the first time, you have done it all before. Then we talked about 'form' in painting and sculpture. In those days painting that wasn't photographic was called decorative; sculpture meant the Greeks and Michelangelo. I had been much impressed by the bronzes brought back by the Benin expedition and shown in Edinburgh. This exhibition was my introduction to Negro sculpture; I liked it then and still like it.

I tell these things to give an idea of what Peploe and I used to talk about. In the days of our early friendship most of my friends were musicians. We were very much interested in the latest music and its relation to modern painting. S.J. was also interested in music and played the piano most sympathetically. I had in my studio one of the first pianos signed by Dettmer. When he came Peploe always played it with complete understanding of the difference between it and an iron-framed grand. S.J. at the old piano is one of my happiest memories.

On fine days I sometimes called at Peploe's studio in Devon Place. When I asked him to come out he would say, 'When it's fine outside, it's fine inside!' Most people don't realise how true that is in a studio planned, decorated and lit for painting. So we sometimes had tea instead of a walk. But we also had long walks and long talks. Often when I had put some idea forward at great length he would say, 'I'll give you the answer tomorrow.' And he did.

In his painting Peploe always sought to achieve a severe synthesis, to express the character of things with the greatest economy of means. This was also true about his letters. It is easy to believe, as a novelist friend said, that he could have been a very good writer. Once I suggested that he should do something outside painting, but he said, 'John, you must remember I'm only a painter.' He didn't mean he was only interested in painting, but that painting was difficult enough for him.

It is strange to think that Peploe started life in a lawyer's office. The lawyer, he said, objected to him spending so much time lying in Princes Street Gardens. So he decided for the Gardens and art. When he announced his decision the lawyer, in the voice and manner of his profession, said, 'Are you sure you have the divine afflatus? You know it is often confused with wind in the stomach.' What was meant by the divine afflatus we can well imagine, knowing the art of that period in the east of Scotland. I think there can be no doubt about the great contribution Peploe made to Scottish art not merely by his painting, which I think is some of the best ever done in Scotland, but because he became a rallying point for the formation of our group which carried on the spirit of freedom and colour started by the Glasgow School.

From the start Peploe and I had been together. When Hunter came back to Scotland from San Francisco after the earthquake Alex Reid made the three of us and Cadell into a group. We became known in Paris as 'Les Peintres Ecossais'. John Ressich, the writer, fought very hard for us with great sympathy and intelligence, and entirely disinterestedly; we were very fortunate to have such a courageous friend to help us to hold out till the younger generation came on, this time from the east.

A thing about Peploe that always astonished me was that he always thought someone else's painting he had read about must be better than his own. Once when I came back from a visit to the Royal Academy, he asked about the Sargents. I told him that I preferred his own painting. He said, 'That's absurd, there must be something wonderful about those Sargents.'

Once, before I had settled in Paris, Peploe came to join me there. One of his first questions was about the new Salon. When I told him what I thought about it he said that I must be completely underestimating it. I said, 'All right we'll go.' After wandering through rooms and rooms he said, 'But take me to the good things. I haven't your endurance for walking round galleries.' I said, 'You've seen it all; you've been right through.' It must have been Peploe's respect for official institutions that made him persist in sending works to the RSA where he was generally rejected.

One year we went together to Islay. In others it was Etaples, Paris-Plage, Dunkirk, Berneval, Dieppe, Etretat and Le Tréport – all happy painting holidays. We worked all day, drawing and painting everything. And we thoroughly enjoyed French food and wine. We agreed on the importance of good food and drink, not fantastic food but good peasant food in France and good Scots food in Scotland – what's better than good steaks and good Burgundy, good beef and good beer. We enjoyed and took time over our meals – time to eat and talk and draw the things on the table. S.J. loved a book about food I had lent him – *Cakes and Ale* by Nathaniel Gubbins. (How he would have loved that wonderful book, *The Scots Kitchen*, by Marian McNeill.) We got a taste for French food and wine and we found a different way of living. We were always glad to get back to it.

I remember when we arrived at Dunkirk I laughed at the lightness of the railway carriages. S.J. said, 'What's the matter with them – aren't they adequate?' That was characteristic of him. In his painting, and in everything, he tried to make things adequate; to find the essentials by persistent trial. He worked all the time from nature but never imitated it. He often took a long time to make contact with a place and was discouraged by a failure. He wanted to be sure before he started and seemed to believe that you could be sure. I don't think he wanted to have a struggle on the canvas; he wanted to be sure of a thing and do it. That gave his painting something.

After the last of our early painting holidays in France, S.J. went back to Scotland and I went to Paris and settled there. Of course we wrote to each other a great deal. I wrote long letters trying to explain modern painting. Something new had started and I was very much intrigued. But there was no language for it that made sense in Edinburgh or London; an expression like, 'the logic of line' meant something in Paris that it couldn't mean in Edinburgh. I find today that most painters don't understand what happened in Paris before 1914 – though hundreds of books have been written about it. This was why I was so glad when, after a few years, Peploe came to live in Paris with Margaret, his charming sympathetic wife.

By this time I was settled in the movement. I had become a *Sociétaire* of the Salon d'Automne and felt at home. Peploe and I went everywhere together. I took him to see Picasso and he was very much impressed. We went to the Salon d'Automne dinner where we met Bourdelle, Friesz, Pascin and others. He started to send to the Salon d'Automne. I was very happy for I felt that he was at last in a suitable milieu, something more sympathetic than the RSA. He was working hard and changed from blacks and greys to colour and design. We were together again, seeing things together instead of writing about them.

Things I really like – perhaps I should say love – often make me want to laugh. One day Peploe and I went to see the Pelliot Collection. As we wandered through it we were suddenly halted, fixed by an intensity like a ray, in front of a marble head of a Buddha, white marble, perhaps, with a crown of beads painted cerulean blue. I can't remember anything in art with a greater intensity of spiritual feeling. We both stood for what seemed a long time, just looking. Then I laughed. I apologised to S.J. for breaking the spell. With his usual understanding he said, 'At a certain point you've either to laugh or cry.'

This was the life I had always wanted and often talked about. We were a very happy group: Anne Rice; Jo Davidson; Harry and Bill MacCall; Yvonne and Louis de Kerstratt; Roffy the poet; La Torrie, mathematician and aviator. Other good friends in the quarter were E.A. Taylor and Jessie King who made a link with the Glasgow School. We used to meet round the corner table at Boudet's restaurant. We were mothered by the waitress, Augustine, a wonderful young woman from the Cote-d'Or, very good looking with calm, live, dark eyes and crisp, curly, black hair, very strong and well made, a character as generous as the finest Burgundy – a perfect type of that great woman, the French *paysanne*. When you came in far too late, tired and empty, Augustine would go across to the butcher and demand through the bars a *bon chateaubriand à quatre-vingt dix*, cook it perfectly herself and present it to you as if you had a perfect right to be an artist. This with such grace that you did not feel in the least indebted. Looking back we realise it is not

possible for us to express our indebtedness; what we can do is to say that every picture we painted at that period is partly Augustine. Her health in the best Burgundy! God bless her! Then there was Madame Boudet at the pay desk, sonsie and easy to look at – and very understanding. When we couldn't pay we did our signed and dated portraits on the back of the bill. After dinner we went to L'Avenue for coffee and music. La Rotunde was then a 'zinc' with seats for three only.

It was in these pre-war days that Middleton Murry and Michael Sadler came over and asked me to be art editor of *Rhythm*. Peploe contributed to it. Later Murry came with Katherine Mansfield. We were all very excited with the Russian ballet when it came to Paris. Bakst was a *Sociétaire* of the Salon d'Automne and used all the ideas of modern painting for his *décor*. Diaghilev made a triumph, surely even greater than he had hoped for. No wonder S.J. said these were some of the greatest nights in anyone's life – *Schéhérazade*, *Petruchka*, *Sacre du Printemps*, Nijinsky, Karsavina, Fokine. But we didn't spend all our evenings at the Russian ballet; there was the Cirque Médrano, the Concert-Mayol and the Gaité-Montparnasse.

This was our life in Paris till the *Grand Prix*. Then, where should we go for the summer? One year we went to Royan where Bill, Peploe's elder son, was born. Another year we went to Brittany. But I had grown tired of the north of France; I wanted more sun, more colour; I wanted to go south to Cassis. I told S.J., but he didn't think it was a good idea – too hot for young Bill. I was sorry, but decided to go without him. One day in the Boulevard Raspail, S.J. saw on the pavement just near his door, a paper with the word 'Cassis' on it. He decided to take the risk. We arrived to find it quite cool, and Bill didn't suffer at all. We had his birthday party there and, after a lot of consideration, chose a bottle of Château Lafitte instead of champagne. Château Lafitte to me now means that happy lunch on the verandah overlooking Cassis bay sparkling in the sunshine.

My studio in Paris was being pulled down so I decided to stay in the south somewhere on the coast between Cassis and Nice. I took a house and settled in Cap d'Antibes. The Peploes went back to Scotland and, very soon, the 1914 war drove me back to London. After that we saw much less of each other. But, whenever I came to Scotland to see my mother, the next person to see was S.J. We resumed our walks on Princes Street as though the break had been of hours instead of years. We laughed a great deal and got a lot of fun out of everything. One summer afternoon we went to the zoo and laughed with the seals but were suddenly checked when an eagle looked at us as though we were mud. We were depressed to see the elephant in his loose box. That's how it was with us. We enjoyed simple things – a good meal, a good picture, the light on a cloud.

As I think about Peploe I remember a day when we were painting in woods near Paris-Plage. The light on the tree trunks set me wondering. What paint should I use to express it? When S.J. came up we agreed that it needed something like pastel. That was the beginning of our awareness that oily paint is not for everything. There were many beginnings like that which each of us, in his own way, developed in his painting. Our friendship and our shared experiences are like the willow pattern plate that brings my mother back to me. When things are really important it becomes impossible to express them except by some extraordinary release over which we have no control.

I am writing too much – just as though I were talking to Peploe. But it is difficult to be brief about a wonderful friendship that lasted a lifetime. It was, I think, one of the best friendships that has ever been between two painters.

This record of Fergusson's friendship with Peploe was written in 1945 and published in Scottish Art Review, *vol. VIII, no. 3, 1962.*